Professional Commercial Photography

Techniques and Images
from Master Digital Photographers

Lou Jacobs Jr.

AMHERST MEDIA, INC. ■ BUFFALO, NY

DEDICATION

To my wife Kathy, who has become a very good photographer, especially on our vacation travels. She is patient when I seem attached to the computer and is a pleasant model when cajoled to sit on a rock at Joshua Tree National Park or pretend she's a tourist at one of the many museums we visit.

ACKNOWLEDGMENTS

I often work with professional photographers who contribute to my books about various topics, and the group that helped me with *Professional Commercial Photography* is typically experts who are enthusiastic about their specialty. I greatly appreciate their help with words about their experiences and advice, plus their fine images that illuminate the pages of their chapters.

Copyright © 2010 by Lou Jacobs Jr.

Front cover photograph by Pete Springer.
Back cover photographs by Cassandra M. Zampini.

All rights reserved.

Published by:
Amherst Media, Inc.
P.O. Box 586
Buffalo, N.Y. 14226
Fax: 716-874-4508
www.AmherstMedia.com

Publisher: Craig Alesse
Senior Editor/Production Manager: Michelle Perkins
Assistant Editor: Barbara A. Lynch-Johnt
Editorial assistance provided by John S. Loder, Carey Maines, and Sally Jarzab.

ISBN-13: 978-1-58428-269-3
Library of Congress Control Number: 2009903895

Printed in Korea.
10 9 8 7 6 5 4 3 2 1

CONTENTS

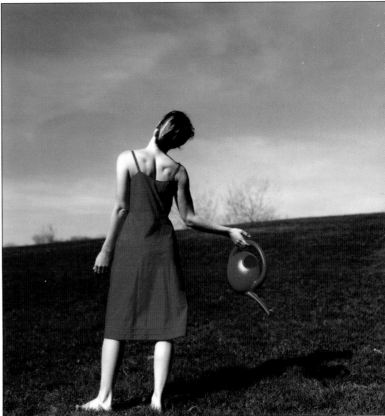

© Cig Harvey

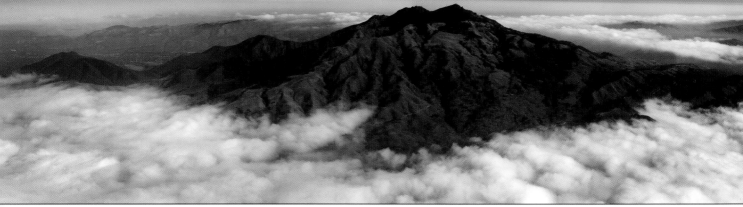

© Todd Quom

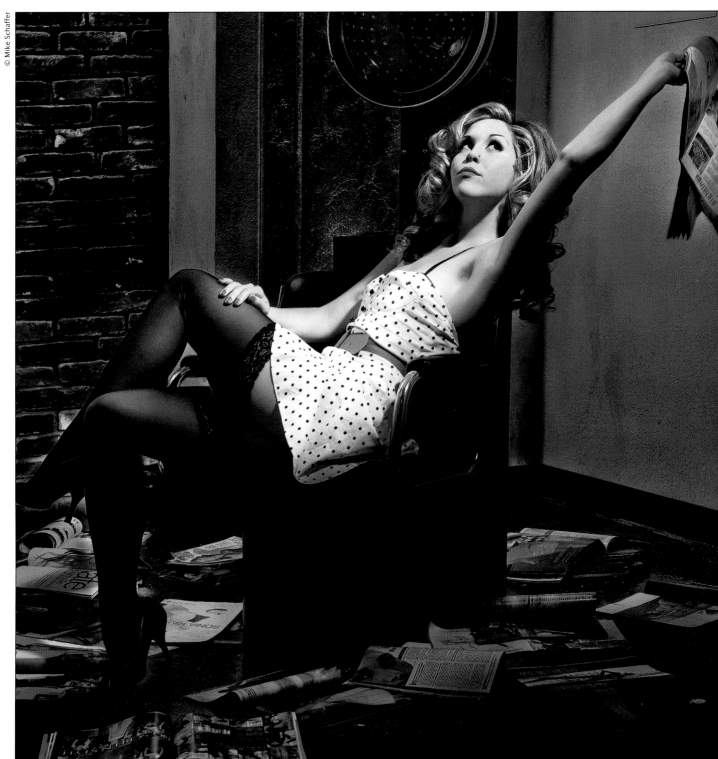

ABOUT THE AUTHOR

Lou Jacobs Jr. says he's an industrial designer (Carnegie-Mellon University), turned photographer (Art Center College of Design), turned writer (the school of occasional rejections). He lived in Pittsburgh, PA, and eventually moved to Los Angeles, CA, where he took root. For many years he shot for magazines and went to New York frequently to visit editors. He was on the ASMP board for many years and is a Life Member. He took six months off to travel in Europe where he shot 35mm and used a 4x5 view camera for fine art work.

After writing for various photographic magazines, Lou was asked to author his first book—about variable contrast papers. More books followed on numerous photographic subjects, plus sixteen other books for young readers on jumbo jets, transportation, the Watts Towers (story written by Jon Madian), marine mammals, space exploration, and American landscapes. In various years he taught photojournalism at UCLA Extension and Brooks Institute in Santa Barbara. For two years he and his late wife (Barbara) lived and traveled in a motorhome crossing the United States and Canada four times. They wintered in Florida, and after returning to the West Coast they settled in Palm Springs, CA, where Lou built another darkroom that's now convenient for storage.

Lou and his current wife of twenty years, Kathy, spent many vacations towing a trailer to visit national parks and photogenic places from Maine, to Utah, to the Northwest. They told friends and relatives, "We bring our house to your house." The couple visited many European countries in rental cars in four different years. They loved many areas such as France and Venice and Salema, a village at the southern tip of Portugal on the Mediterranean where iron ore in the rock cliffs colors them bright orange. Now they often visit Joshua Tree National Park, which is an hour or so from home. "There is no limit to rock formations to photograph," Lou says.

Lou has written and illustrated thirty-seven books on photographic subjects and continues to write for *Rangefinder* and for his favorite publisher, Craig Alesse at Amherst Media.

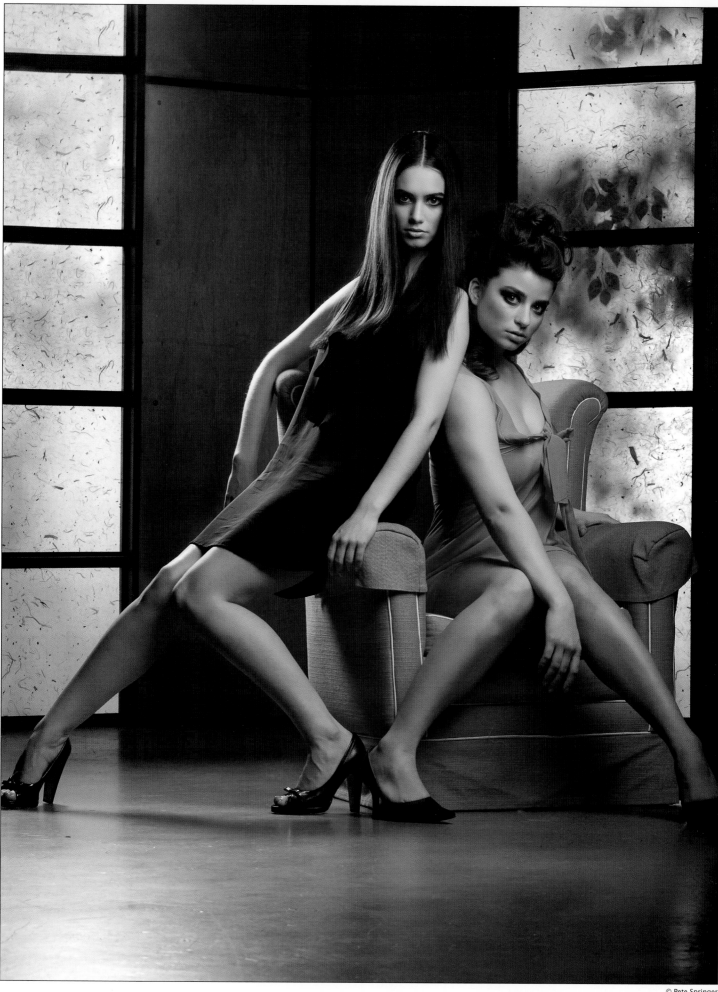

INTRODUCTION

The greatest tool at our command is the very thing that is photography. Light. Light is our paint brush, and it is a most willing tool in the hands of the one who studies it with sufficient care.—Laura Gilpin

WHAT'S AHEAD

Commercial photographers create images to sell products, services, political candidates, organizations, corporations, etc. This book contains a compilation of stories, strategies, and striking images from commercial photographers at the top of their fields. Though many concentrate on one or two specialties, every contributor is versatile. Here are tidbits about the photographers who will be sharing their advice and experiences in the chapters that follow:

- Doug Edmunds has a large studio where he shoots a variety of products, and he's also a location expert.
- Gary Hartman photographs architecture, advertising subjects, and annual reports.
- Cig Harvey does advertising illustrations, usually on location.
- Cassandra M. Zampini photographs many types of still life and products, mainly for advertising.
- Wendy Nelson operates a studio called Blue Fox Photography and shoots business activities and family gatherings.
- Todd Quom does impressive aerial photography.
- Mike Schaffer photographs a variety of products and builds sets for some.
- Sal Sessa covers events such as conventions, meetings, and VIPs giving out awards.
- Darren Setlow shoots architectural interiors in homes and factories.
- Pete Springer photographs fashion shows and models, on location and in his studio.

All contributors explain how they approach imaging and how their business operates. They describe getting started. They tell you how they attract clients, what equipment they use, and what their tastes are in commercial work. Here are a few examples of what's ahead: Doug Edmunds and a large crew spent days shooting home interiors for a company that makes carpeting. Mike Schaffer built a set in his studio to resemble part of a barn, creating an environment for a clothing company catalog shoot. Cig Harvey once photographed a truck in a snowstorm from a tent her crew built for her. Todd Quom shoots buildings and landscapes, mostly in Western states, from a plane with a space in the floor for his camera. Sal Sessa has an adjunct business that does individual headshots at group gatherings.

CLIENT EXPECTATIONS

Among client categories that need commercial photography are: ad agencies, manufacturers, retail stores, hotels and resorts—and the list goes on. Businesses involved with consumer products often employ freelance shooters who may work from a studio, with a separate office, or improvise a studio at home or as part of an office. Some large companies have studios that employ lots of shooters. Examples are department stores, manufacturers, and other types of business. A friend of mine made a satisfying twenty-five-year career shooting for Bethlehem Steel until the company folded.

All contributors to this book run their own businesses. Since photographers can display work so conveniently on their web sites, it's easier for clients to discover them today than it was when portfolios of prints and transparencies were carried or sent to clients. It is not difficult to set up a home photo studio with backgrounds or settings to gain experience

© Gary Hartman

photographing small products or sometimes people. There are also commercial situations you may shoot on location.

SPECIALIZING

Many professionals don't set out to specialize. As they get established, they shoot lots of different products and services, and one phase of commercial work may captivate them, or they may be offered an attractive opportunity in a specialty like home furnishings. Some decide to work in more than one field. Among the specialties you'll read about are aerial photography, products, architecture, fashion, annual reports, adver-

tising, and events. Adjuncts of those are food, cosmetics, small appliances, clothing, high school proms, cars, theater and dance, and more.

QUALIFICATIONS

Obviously, all commercial photographers should be experts in composition and have a keen sense of lighting. Catalog photographers shoot merchandise like shoes, kitchen appliances, lingerie, and photographic equipment. You may work on location with a big budget and a crew for big fees, or you may be on a modest budget shooting whatever challenges you. Annual reports and advertising pay the best, and they are

the most demanding and hardest to get into. If you create a reputation for yourself in these fields, you can be in demand, and your agent may negotiate for you.

The above discussion is both fact and fantasy. A great number of photographers create good reputations in fairly limited circumstances. They are not famous, but they stay busy in their areas and beyond. Photographers face slow periods, so some may shoot personal projects to stay sharp and add to a portfolio. Some of the best inspiration is the kind you generate for yourself through curiosity and opportunities you discover or generate.

WORKING IN THE FIELD

Architecture is another demanding specialty. Clients are architects, builders, construction companies, and magazines, all of which want precise and attractive depictions of their structures inside and out. It helps to have knowledge of art, design, and home furnishings to make buildings and interiors look glamorous. It may be easier to glamorize pretty models who need portfolios, or actors on their way up.

Events practitioners photograph people at conventions, meetings, and celebrations, and the pictures are used for public relations, company newsletters, or newspapers. Event photographers follow and record VIPs at public and private openings and during factory visits. At graduation dances where the crowd is well dressed, event specialists take portraits of couples and groups and make prints available in an hour. Executives at events are also impulse portrait buyers.

Industrial subjects can become commercial bread and butter. You may document a company's factory operations or shoot special events. When they need daily photography, companies often hire salaried shooters, and staff jobs can pay as well as running your own business. A weekly income can be more appealing than waiting for freelance checks. You can be your own freelance boss or opt for being an employee with work and salary security. You can grow your own business with your name on it or deal with company bureaucracy but know when checks are coming. One chooses according to temperament and opportunity.

Freelancers like setting their own hours and enjoy the ability to vacation when business is slow.

So, how much can you earn as a generalist or specialist in commercial photography? It depends on how much you hustle, how well you promote yourself, how artistic or craftsman-like you are, whether a specialty you choose is popular, and how affluent your clients are. Most contributors featured in this book explain how they charge for various types of work. A good income also depends upon good business practices, negotiation skills, awareness of your capabilities, and eagerness to do top-notch jobs. Good self-esteem also helps boost income.

To summarize, commercial photography requires a mixture of photographic skills and responsibilities. It offers numerous rewards in accomplishment and dollars. You need determination to succeed in a studio, home office, or factory. Patience, good intuition, talent, and an ingratiating personality also pay off.

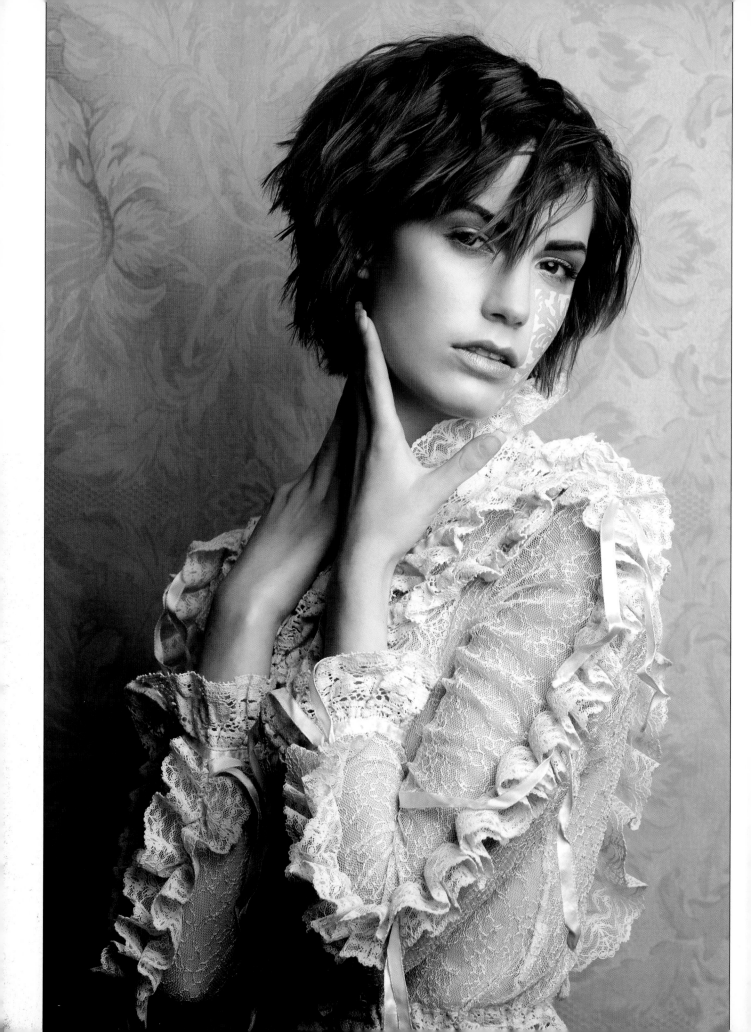

1. PETE SPRINGER

Pete Springer of Portland, OR, became interested in photography in junior high after taking a class that included darkroom training. He soon began shooting photos of friends and family, and in college, he contributed photos to the student newspaper. Upon graduation, he found himself working alongside wildfire-fighter crews. He always had a camera handy and discovered that fellow crew members would buy nice portrait-style photographs of themselves. Soon he was more interested in shooting cool photos than putting out fires. After selling prints to the National Park Service, he knew he had embarked on a career and soon discovered commercial photography. For more information, visit Pete's web site at www.petespringer.com.

DISCOVERING FASHION

Being serious about shooting, I studied journalism and photojournalism, and began freelancing. To augment my income I got a job with a local news radio station that needed pictures for its web site. When they sent me to Egypt (yes, Egypt!) to shoot pictures of local soldiers enforcing a peace treaty between Egypt and Israel, I was really entranced.

To take more effective images, I signed up for the New York Institute of Photography professional photography course, and when the fashion photography section came up, I knew that's exactly what I wanted to do. To meet local designers, I shot every available fashion show for several months. My gambit worked,

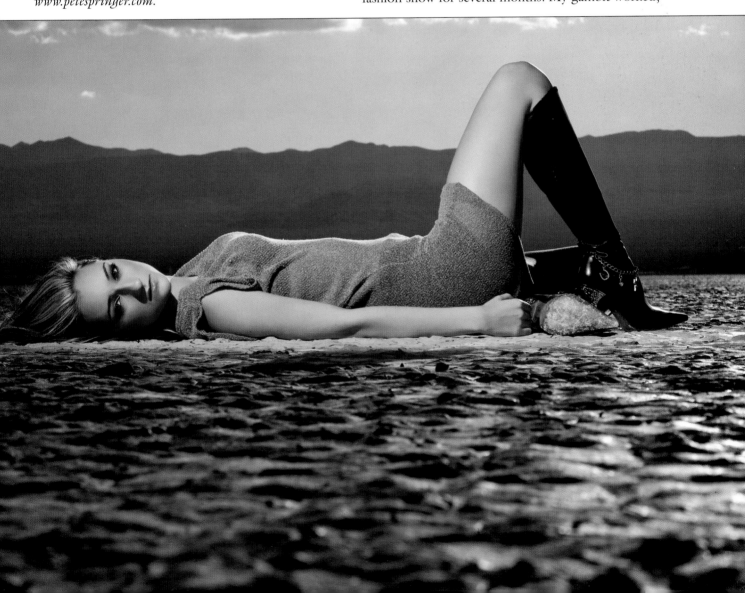

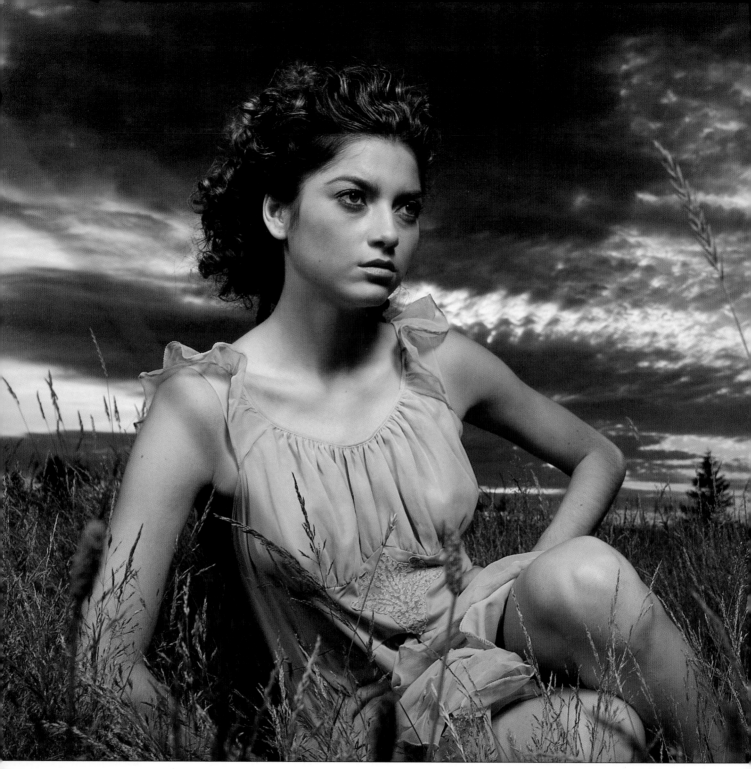

and I met models, designers, and makeup artists as I became more fashion conscious. I also made extra money selling prints.

I still do freelance photojournalism for events such as when presidential candidates come to town, and I do photo essays in conjunction with radio reporters. But photojournalism can be about gritty reality, and I find fashion so much more beautiful. It's about selling a fantasy, and it's a lot more fun to shoot.

BUSINESS PROMOTIONS

My fashion clients range from local designers, to event planners, to models who need new images for their portfolios. I rely heavily on SEO (search engine opti-

STUDIO WORK

I prefer to shoot outdoors on location when possible since there's more variety in backgrounds and I can usually make the ambience fit my pictures. I also use rental studios. The main one is a massive television studio during the week, but the manager arranges for me to use it on Sundays when nothing else is going on. It's big enough to shoot a full-length shot of a model with a 200mm lens.

MUST-HAVE ITEMS

I light just about everything I shoot, even outdoors. I have a full set of studio strobes, currently six heads, and a ring flash (circles the lens for shadowless lighting). The power comes from portable battery packs, products from Paul C. Buff. I love his White Lightning monoheads and am quickly growing to love his Zeus battery-powered pack and head system, which allows me to work anywhere without A/C availability (this system also works with a ring flash). I also use several Canon hotshoe units.

My light modifiers include softboxes, Stripdomes, grids, an Octabox (a large, eight-sided softbox), silver umbrellas, a white umbrella, a translucent umbrella, background stands, gels, and barn doors (to mask light from parts of a subject). Everything is portable and fits in the back of the car, and most of it (with the exception of a few stands and a couple of other items) fits in a large contractor box on wheels.

My absolute don't-leave-home-without-it tool is a stepladder. When you regularly work with 6-foot-tall models wearing high heels, you need to be able to get shots at, or above, their eye level. A ladder also helps you capture everyone's face in a group shot. Extension cords are mandatory, as is at least one power strip (multiple A/C outlets). I always try to bring an iPod with external speakers in case there isn't music on location.

NOTE ABOUT THE IMAGES

The photos in this chapter were created for specific clients. My clients include a number of local clothing boutiques and designers who often need photos for

mization) to promote my work. I've tried postcard mailers, cold-calls, etc., but most of my business comes from clients who find me on the Internet. Search engines such as Google find me because I keyword and title my images. They recognize words and linked photo titles. A separate blog also helps me to promote my work online.

advertising in local publications. I also frequently shoot model portfolios, which generally require a mix of fashion and beauty shots. Locations are chosen to complement both clothing and the models. I work closely with models, designers, hairstylists, and make-up artists when creating images to make sure the final product is what they need. That literally means some of these images required hours of preparation, from wardrobe styling, to lighting, to hair and makeup.

WORKING WITH FASHION MODELS

Lighting fashion is similar to portraits, but models are generally more comfortable in front of the camera than average subjects, and they take direction better. A good model will make suggestions and have ideas about how to make the best photos of them. Portraits are more about getting a subject to relax so their personality comes through. Fashion is more about showing the clothing looking its best. Every location is different. I take the time to light the model properly, no matter whether the shoot is taking place in an old house or warehouse or even a city street—or wherever the client wants.

I often use the same models for various fashion shoots. The more I work with a model, the better the photos, because we understand each others' strengths and we play off that. Fittings usually happen the day of a shoot, but I always carry clothes pins, clips, and safety pins just in case the fit needs a bit of altering.

PHOTOGRAPHING FASHION SHOWS

I shoot runway shows with hot-shoe strobes because many shows are small and in places where the lighting needs to be boosted. The trick is to use fun foam (a white foam available at craft stores) that works great to diffuse the flash. Meter it so existing light is about a stop more than your fill light. I also bring a portable lighting kit (stands, hotshoe strobes, and a shoot-through umbrella) to shows in case there's a chance to photograph designs before the event. These are always the best photos.

OTHER PHOTOGRAPHY JOBS

One of my services is to provide catalog-style shots taken at clients' clothing boutiques. They hire a model, I set up a white background in the store and arrange a basic lighting setup with an umbrella as the main light, two lights on the background, and one light as a kicker (accent light)—then we shoot. The model quickly changes outfits, and as long as I meter and white-balance properly, I can pretty much burn a CD or DVD after the shoot. The store ends up with photos they can use online to sell clothing. For these

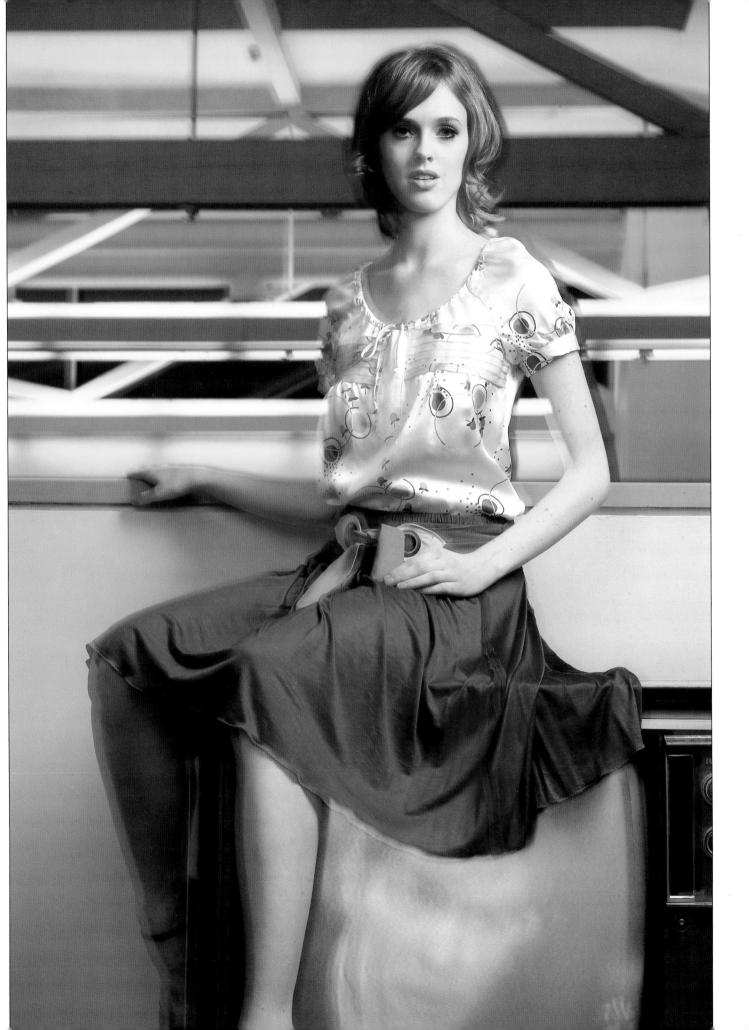

jobs I offer a four-hour shoot for a single price—with as many outfits as we can shoot in the time period. Those photos are for Web use only, and I negotiate for other uses if necessary.

I've also been hired to shoot paintings in an art museum for a television program that needed still photos for on-air uses. It's similar to catalog shooting. At the museum, I set up my lights and camera, and they place the paintings for me. I take care to position the camera perfectly parallel to the frame to avoid tiny reflections from oil and acrylic surfaces.

CAMERA EQUIPMENT

I use Canon equipment. My camera is rarely tethered to a monitor because I'm very active and jump around so much that I usually trip over cords. I frequently

show the client images on the camera back, and it's a good way to build rapport with a model. When he or she sees you're taking cool photos, they'll work harder.

At fashion shows I use a Canon 5D with a 16–35mm lens and a Canon 1D Mark IIn with a 70–200mm lens. For studio work, I prefer the 5D since the quality is amazing. I tend to do photojournalism with a Canon 40D and a 24–70mm lens for its light weight and versatility. I prefer f/2.8 fast lenses, but I also use a 24–105mm f/4 lens for its wide zoom range. It also works well with a ring flash.

A FASHION SHOOT TEAM

My crew consists of a makeup artist, a hairstylist, and sometimes a wardrobe stylist. I've worked with assistants in the past, but I prefer to shoot alone and ask a hairstylist or makeup artist to hold reflectors or lights that tend to blow over outdoors.

Elaborate setups are common for fashion, and I frequently use at least three lights. I like kicker lights for beauty shots. (A beauty shot is a headshot similar to a makeup or hair advertisement, with emphasis on the model's facial features.) My main light is above the camera, two fill lights are in umbrellas below the camera, and a kicker (or two) are on the back of the model, with another light on the background.

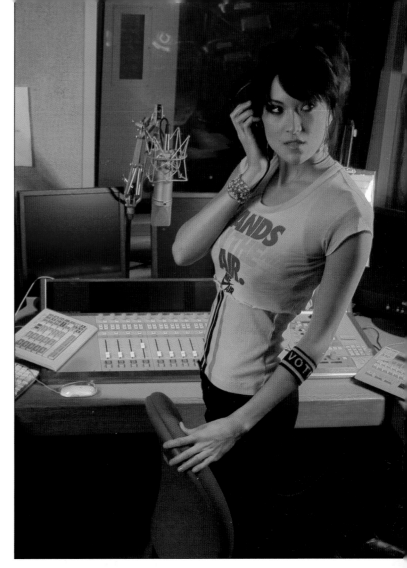

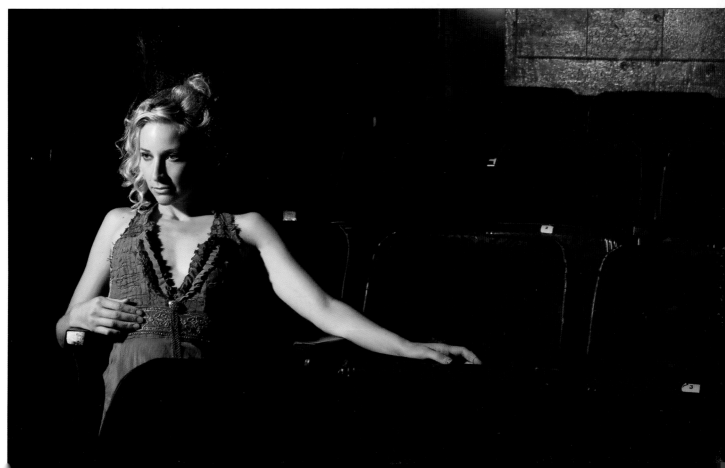

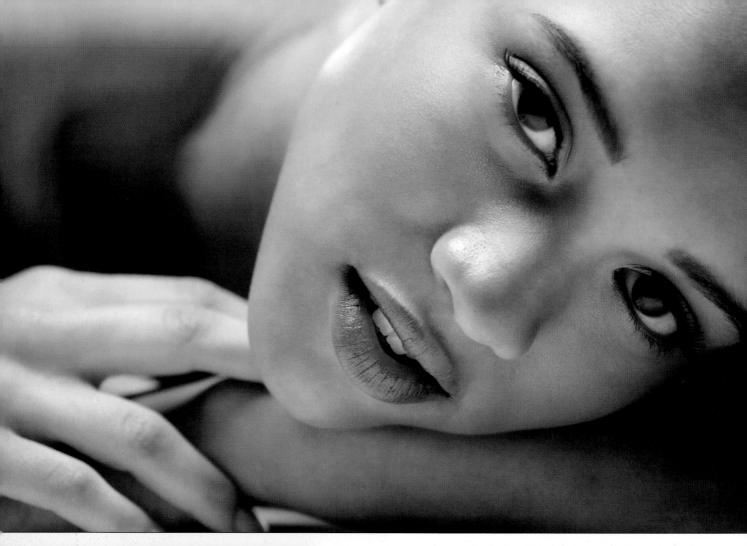

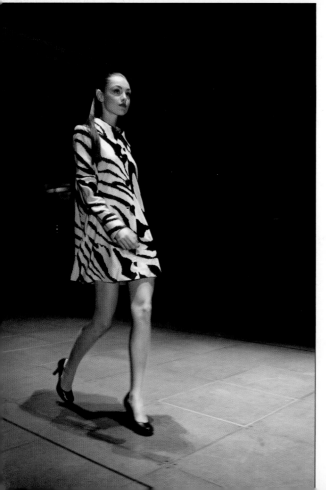

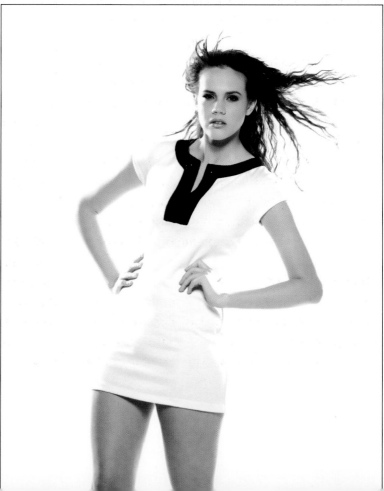

EDUCATING CLIENTS AND MODELS

My clients are welcome to stick around for a shoot, and I find new clients always want to be there, while long-term clients just trust I'll get the assignment done. During much of the basic catalog work, the client knows what to expect and waits for the CD/DVD of images rather than hanging around. I guarantee clients that I'll get their proofs posted to a private, password-protected gallery within a week of the shoot, and most are delighted with my turnaround time.

When clients need gentle reminders about what's possible on a shoot, I encourage them to show me fashion photos they like from magazines so I have a feel for their preferences. But it can be a bit tricky to explain that a Steven Meisel shoot for *Vogue* had a $200,000 budget including formal dresses at $1000 and up, expensive models, and distant locations with full production crews for an entire week. Clients don't always realize why my photos of their friend in a living room don't look like classy magazine layout shots.

However, showing a client some previous work that featured models from an agency can go a long way in convincing them to hire models. It's often said that casting is 80 percent of a successful fashion photo, and that can be difficult to explain to a client with a small budget.

Models tend to have a better sense of what to expect during a fashion shoot than my clients do, though sometimes shorter models don't quite understand why taller ones are best for fashion shots.

I shoot in a number of fashion show locations, and lighting is crucial to how the pictures turn out. When poor lighting on a runway prevents images from being their best, clients need to understand that big fashion shows are more photogenic, and there's a limit on my being able to make small fashion shows look as cool.

MODEL PORTFOLIOS

Model portfolio shoots are a small part of my business. For one reason, most models who are even remotely good looking or talented will have lots of photographers willing to work with them for free for

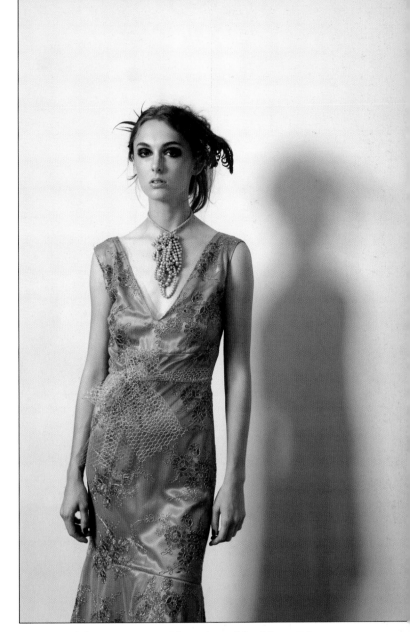

their portfolios. However, I have been hired by models for their portfolio shoot and later use them on a commercial job. I try to convince models that when they hire me, they'll get a photographer plus an expert styling team who will really make them look their best.

POSTPRODUCTION

I currently handle all postproduction myself. I've used third-party retouchers in the past but could not justify the expense or time. The results are great, but it can cost $150 to get ten photos retouched, and that can take up to two weeks. It's faster and easier to do it myself.

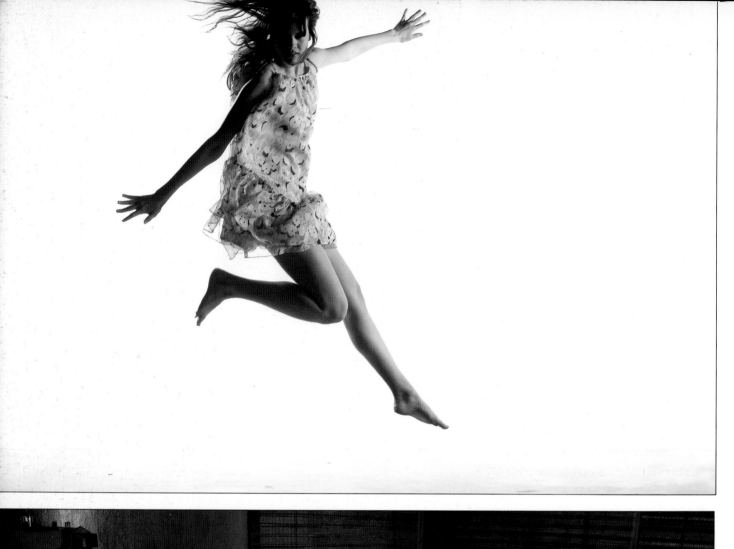
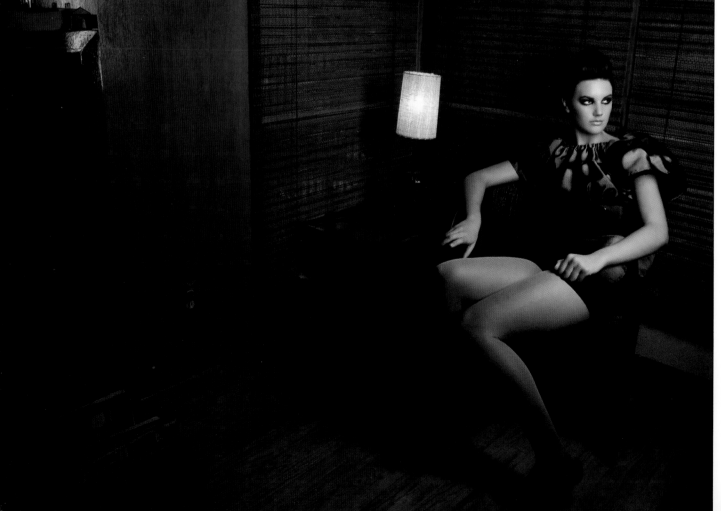

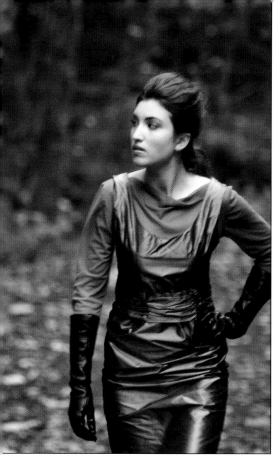

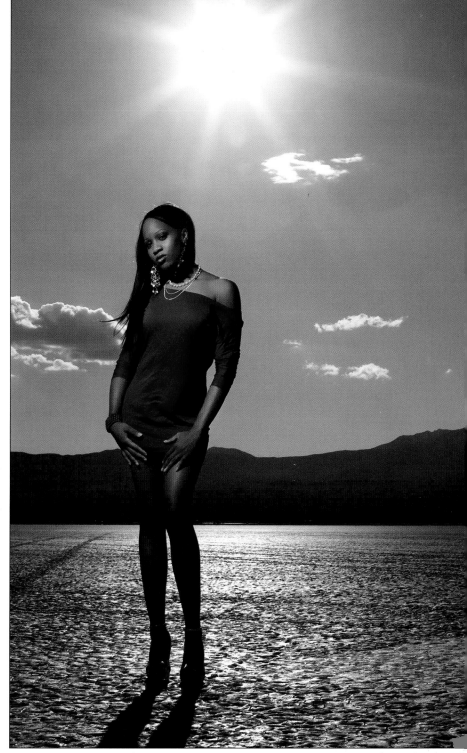

That said, I'm constantly studying books and forums to learn better retouching techniques. Unfortunately, I sometimes spend more time retouching in Photoshop than I do shooting. It takes about fifteen minutes per photo to do a decent retouch and to prep the photo for printing.

PROTECTING USAGE RIGHTS

I sell only usage rights to clients. Depending on the client or the job, I usually make it clear how they may use the images and for what period of time. This is a major challenge because clients tend to think they paid me and therefore own the photos. I've even had clients tell me they wanted to decide what images of their designs I could use for freelance projects with magazines. I explain that our rights agreement gives me the opportunity to sell to magazines, but it's sometimes tricky to do so without upsetting the client.

I rely on usage agreements from ASMP or books on legal issues that include forms for photographers.

It's more of a challenge with a client who doesn't deal much with photographers. Check www.asmp.org or other online forums for rights information.

I watermark (imbedding copyright and my name) fashion show photos when I post them, but even so I find a lot of them on social networking sites. Most of the time, I just let these slide since the models are not selling my images. Sometimes a good way to approach

a model is to say, "Hey, I notice you like my pictures. I offer portfolio shoots if you're looking for something really cool!"

BUSINESS DETAILS

My services and print prices are based on my local market, my skills, the cost of studio rentals, and business goals I set for myself. For example, I can deliver files online now for virtually no additional cost or time. So when a client requests a CD in addition to the online gallery, I charge them $25 for the CD. This is a pretty standard rate. Most clients decide downloading the images is a more economical method.

I have a rough business plan, but as my business grows, I will be creating a more definitive plan to cover details that can guide my growth. I have a tax consultant who helps me with business decisions. Future business plans will include working (hopefully) with local modeling agencies and more local designers. I'm always trying to learn more and to expand my skills in both photography and retouching.

TIME OFF

Arranging for time off from my photography business involves not scheduling shoots, or working part time.

This requires planning to make sure I have earned enough in other months to cover the expenses and lack of income during a vacation.

INSPIRATION FROM THE FIELD

I read many professional photography magazines. My favorites are from the UK, and I also love *PDN (Photo District News)*. I also look at many fashion magazines, such as *Vogue, Marie Claire,* and *Elle;* I get a lot of inspiration studying images shot by the big-name photographers.

PHOTOGRAPHER'S PERSONALITY

Your personality can help attract clients. I require pre-shoot meetings with clients, and a large part of the time is spent convincing them indirectly that a shoot is worth a certain amount of money and that I'll deliver better results than anyone else. The friendly way I present my case helps clients understand—and like me as well.

It's important to follow up and thank clients for hiring you. The best clients are those who use your services over and over again. They sometimes need convincing that you're really worth your fee. That's when sincere empathy helps.

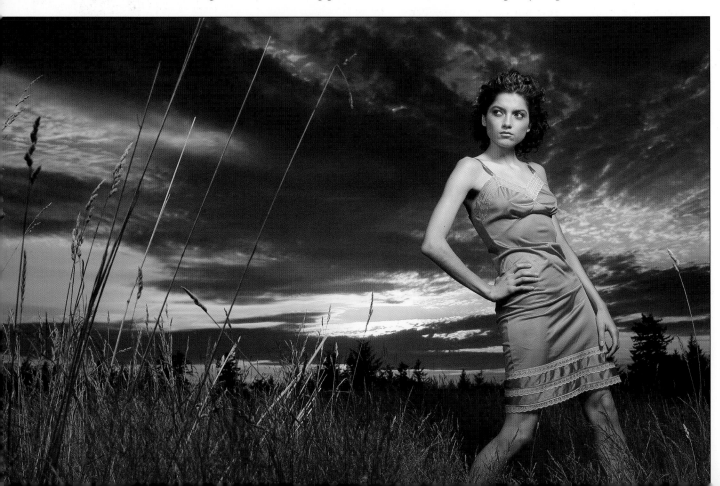

2. CASSANDRA M. ZAMPINI

Cassandra M. Zampini did her first photographic job in high school shooting portraits of graduating seniors. As a junior at Boston University, she got a summer internship with New World Outlook *in New York City as staff photographer and writer. At one point, she went on a weeklong assignment to cover the economic situation in South America. The magazine was excited about her work, and Cassandra became their parent company's principle photographer. She did everything from corporate events to ad campaign shoots. It was a fortuitous beginning. For more information about Cassandra, visit her web site at www.cmzphotographics.com.*

EARLY EXPERIENCE

After my internship, I continued to work with the magazine as a freelance writer and photographer. I was also a reporter and photojournalist for a local paper in Connecticut, and I constantly freelanced for other companies, doing marketing photo shoots and corporate events. Eventually, I grew out of the newspaper business and started on my own as a commercial photographer.

STARTING OUT

Starting a commercial photography company was not easy. It took months to learn how to build my own web site, learn personal sales techniques, and find new corporate clients. A few existing customers helped me to develop the confidence I needed at the beginning. Those companies allowed me to grow and strengthen my business and to build experience.

My company specializes in custom product photography solutions (e.g., photo projects from ten-foot-high boilers to tiny pieces of jewelry) and product application photography (e.g., lighting fixtures installed in architecture, to models showing off products like handbags and lipstick). The similarity

between the two kinds of photography I do is that in both cases, I strive to show off a product and to market it to the customers my clients are trying to reach. Typical clients are small manufacturers, business owners, and advertising and design agencies. To help clients through the process of creating an advertisement that best represents their product, I have estab-

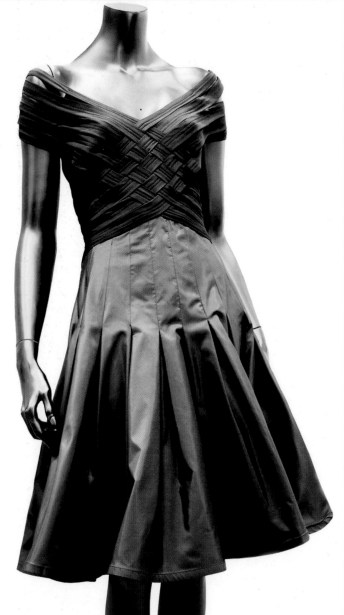

lished relationships with graphic designers and printers that I trust.

A BUSINESS PLAN

When starting a photography business, it is important to determine the direction in which you want to take your business—including what you want to shoot and who your desired demographic will be. Your business plan should reflect your goals and guide you in making decisions about your business. Until I actually sat down and wrote out an entire business plan, I felt like my company was beginning to float off in different directions. I was doing jobs that were actually hurting the business, since the clients I was working with were not really my target. Creating and implementing a business plan helped me focus my marketing strategy on customers I really wanted to work with.

MY STUDIO

My photography business is located in Lowell, MA, a town about thirty minutes northwest of Boston. The studio is in a large renovated factory where there are three floors of studios for artists working in various mediums. My studio is approximately 850 square feet, with a sitting area for clients, a dressing room for models, a postproduction area, and a stage set up with 15-foot-high backdrops for products or models.

The studio is fully equipped with professional lighting and studio accessories for a variety of subjects and creative setups. I keep food and refreshments available for clients who wait to see images after a shoot.

Many of my clients prefer work to be done at their company locations, so I often travel locally and nationally to do executive portraiture, cover events, or photograph equipment too large to send to my studio. Products too heavy to move require having a studio set built around them on site. Finally, the images are edited in Photoshop to prepare them for Web or print use.

LIGHTING EQUIPMENT

I rely on Hensel professional-grade monolights (500 watt-seconds or higher) and Chimera medium and

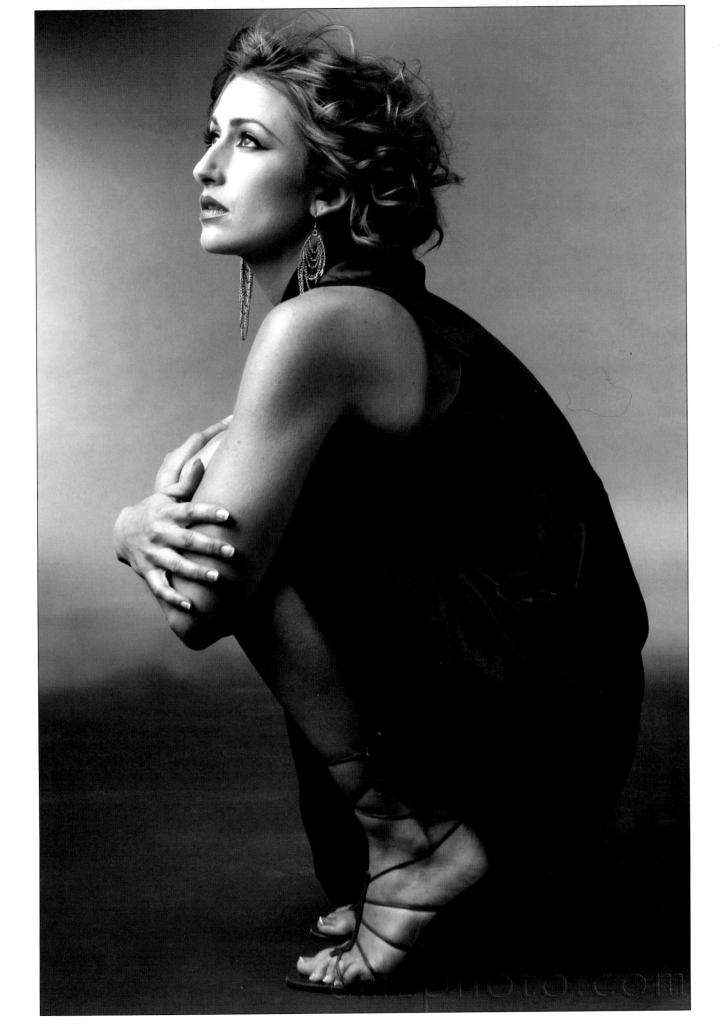

large softboxes for products, ad shots, and architectural interiors. Nikon SB-800 Speedlights are great for small, on-location jobs and event photography, but for larger products and action shots, I go with the monolights.

When the assignment requires photographing people and small products, I often carry my Nikon Speedlights with me on the plane. For jobs outside of my area, renting monolights or battery packs at the location city is the most practical option. If I'm driving to the assignment, I transport almost all of my gear, including three Hensel monolights, two background set-ups, rolls of paper, tripods, light stands, reflectors—you name it. I also bring different kinds of filters to match the color temperature of the lights at an architectural shoot. When photographing a product on location, I may need reflectors, softboxes, grids, or

gobos to get the perfect light. I feel more confident to accomplish an assignment when I have an array of equipment on hand.

PRODUCT PHOTOGRAPHY

Lighting still life or small products can seem difficult until you have enough experience to tackle challenges that arise. At first, still life products required a lot of patience, especially when I was a beginner using homemade studio setups. Having the patience to get that perfect shot with a perfect angle and lighting was the hardest thing to learn. You have to love the process, not just the end result.

For me, there is really no one formula for lighting different commercial subjects. How you do it depends on the objects and what the client is looking for in your photographs. You have to apply everything you know about photography for a short period of time. That, in a way, becomes your own secret formula for creating the images that will be successful.

Reflective Objects. Depending on the size of the object and the amount of its reflective surface, I will build a tent-like setup around it in order to diminish or prevent reflections or glare. Using large softboxes

or umbrellas helps to achieve the quality of light needed, and using gobos helps create nice contrast on the object itself. Every setup is somewhat different. Sometimes, there is just no way to diminish a reflection coming from your camera lens, and this is where postproduction work comes in. To get that smooth transition and to remove dust or tiny imperfections on the product, postproduction is key.

However, postproduction work is a whole other set of skills and should be treated as a special undertaking. This is why I tend to price product photography differently if there is lots of postproduction needed to acquire the client's desired result. I take the time to finesse the images myself or outsource the work to a reliable designer.

COMMUNICATING WITH CLIENTS

If you show up at the shoot with a concept that does not mesh with the client's expectations, you may have an unhappy client and may need to schedule a reshoot, which isn't always feasible. To avoid a situation like this, be sure to schedule conversations with your clients and come prepared with a written set of questions that you can address early on in the planning stages for the session.

When a job is complex, or simply to ensure that you and the client are on the same page, follow up your conversation with the client with an e-mail that outlines your combined expectations. You might also include in your e-mail an outline of some photographic ideas that will make a good impression.

Communication on short shoots should be easier when the job has been discussed, even briefly. However, when a shoot takes a day or more, it's good practice to talk with the client as often as you feel either of you need guidance. Sensible communication smooths the way and boosts your confidence.

CHALLENGES

My biggest challenge (but also the most rewarding part of product photography) is conceptualizing

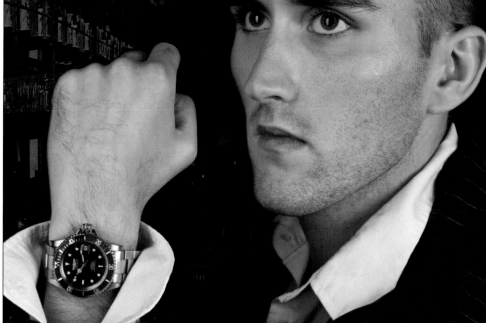

creative ways to photograph products that best convey the client's message. Using a model, going on location for an architectural shoot, and photographing products in the most tangible and artistic ways are the most enjoyable aspects of the job.

CAMERAS AND LENSES

When doing commercial shoots where the graphic designer needs to review the image in order to achieve the perfect angle for the advertisement, having the camera tethered to a monitor is ideal. It's also very helpful when clients want to observe what I am shooting, and it fulfills their need to make suggestions.

I prefer Nikon cameras, and the Nikon D3 is great for high-resolution shots and is still portable. I use my Nikon D200 most often as a backup. I prefer the AF Nikkor 24mm f/2.8D wide-angle lens for architectural shoots, and I use the Nikkor 60mm macro lens for product close-ups.

BACKUP EQUIPMENT

One key to successful on-location photography is to have backup lighting equipment, batteries, lenses, cameras, and accessories. You never know what can happen. Once I was shooting a fashion show and one of my Speedlights died. I had a backup unit, so I didn't miss innumerable shots, and the client may not have noticed that anything happened. Being prepared for the unexpected is always good business.

project, the costs of travel, assistants' and models' fees, and the amount of postproduction work that's required. Usage becomes a key ingredient in pricing, though you may have to educate certain clients about it. As an example, if you shoot an attractive still life for the cover of *Time,* the fee might be $2500–$3000 because of the magazine's large circulation and high advertising page rate. If the same shot were used on a local magazine or in a local ad, the fee would be much lower because the image would have less dollar value related to circulation and ad space rate.

Negotiating fees and job details require experience, and each time you negotiate a deal where you and the client are satisfied, you are both winners, and your confidence increases. Some clients on a limited budget need to learn what to expect from a photographer, and vice versa. When you accept any job that requires a day or more of work—plus pre- and postproduction— for a fee that does not guarantee a reasonable profit, the future of your business will suffer. It is also unrealistic for a client to expect the highest quality of work from a photographer who is not making a suitable profit. Unless you agree to a price that is mutually comfortable, you may be sacrificing your quality of work and reputation.

POSTPRODUCTION

I handle postproduction work in my studio, unless it is a high-volume job or I am working with a graphic design company for a mutual client. When working with a big budget, outsourcing can be the way to go.

Having a working knowledge of Photoshop is as important as it was to know how to develop film and make excellent prints in the old days. Having the postproduction skills allows you to finesse your images for a more polished, professional look and can help you to add a touch of your personal style to the final product.

ACCOUNTING

When you are getting started in this business, it is a good idea to hire an accountant to help you keep a level head. I have a CPA and a financial advisor who assist my company with business decisions.

ASSISTANTS

I hire assistants for some photographic operations. I may also call in hairstylists and makeup artists.

PRICING AND FEES

My photography fees vary depending on the complexity and usage of the work. I generally price my photography services based on time, the scope of the

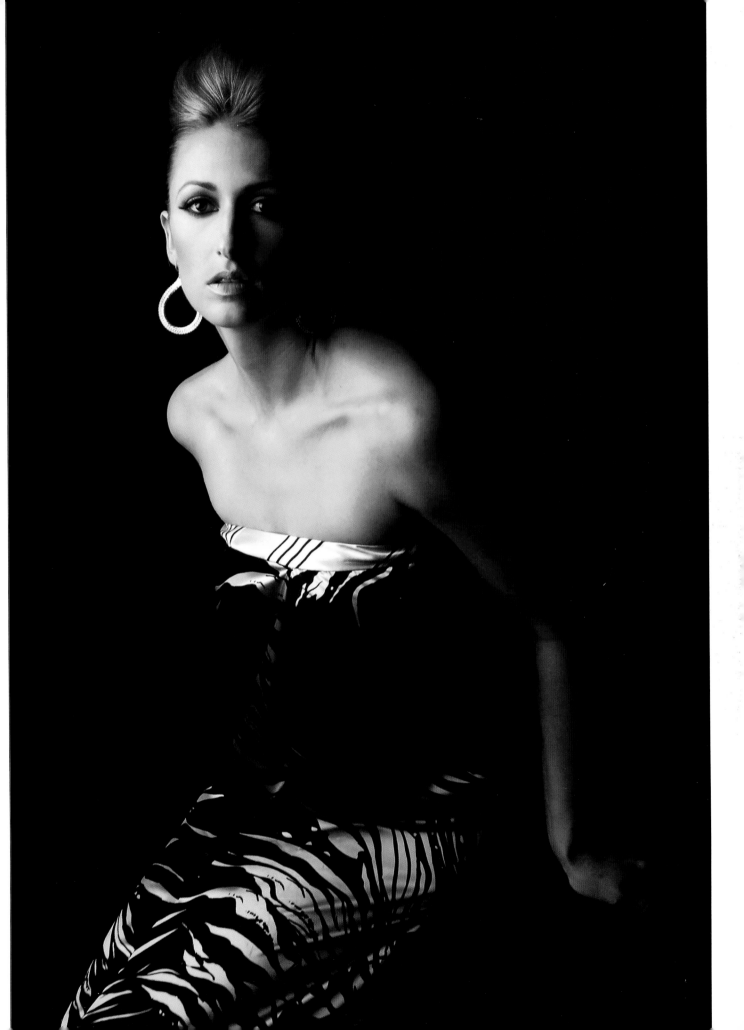

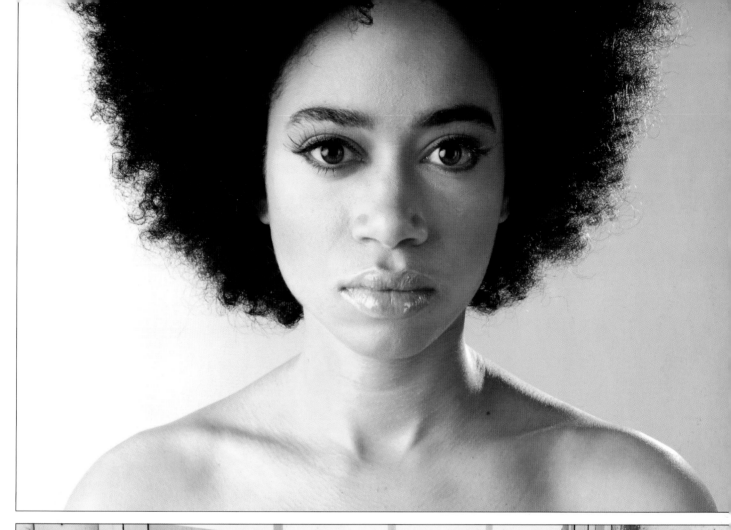
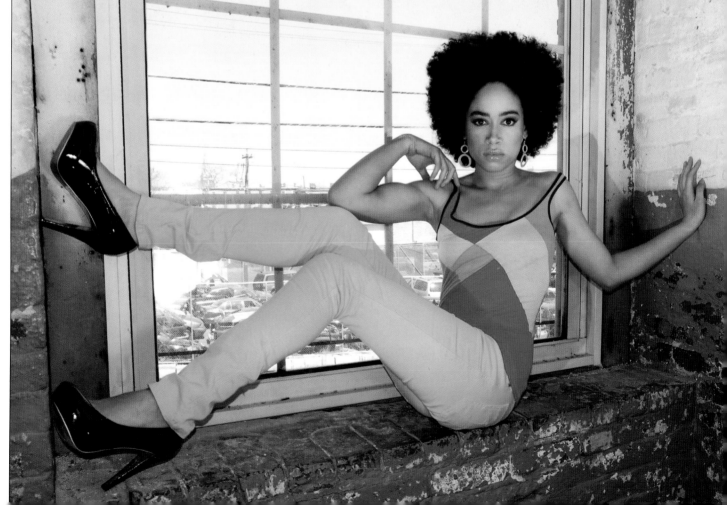

pared to present your company in front of twenty or more people, as some networking groups require this.

FUTURE PLANS

In the future, I would really like to photograph mostly product application shots, as they are the most challenging for me. I enjoy shooting products for catalogs, web sites, etc., but photographing the same products in an innovative way for my clients is a great path to creativity. Collaborating with models and assistants is also fun and challenging and requires a great deal of teamwork.

STAYING IN THE LOOP

I belong to the National Association of Photoshop Professionals (NAPP) and the Advertising Photographers of America (APA). I read Photoshop magazines—plus a variety of photography magazines—on a regular basis to keep up with the new technology.

THE REALITIES OF THE BUSINESS

Many new photographers do not realize how important it is to learn how to run a business. They may believe that they will be able to spend the majority of their time shooting, only to realize that much time needs to be dedicated to growing the business, keeping customers happy, managing customer accounts, and fine-tuning images in postprodction.

PROMOTING YOUR BUSINESS

I promote my business best by participating in networking groups that can generate referrals. Networking has proven to be my most valuable marketing tool for the time involved. The human connection is far more valuable than a cold call or e-mail, but be pre-

I work hard to photograph every day, but some days are interrupted by many business details. Photographers who want to make a living in commercial photography should understand that the business segment is as important as taking great images.

Wendy Nelson's business, Blue Fox Photography, is located in Colorado Springs, CO. She operates with a staff of four and does most of the shooting herself. She earned a jounalism degree at the University of Vermont in 1977.

Wendy is an enthusiastic person who enjoys the process of advertising and marketing her business. She says, "I once lived by the premise that if I had one client and kept her happy, I'd surely get more clients. When people have a good experience, they want their friends to know." This approach worked, and referrals were and are still numerous. Blue Fox serves corporate clients and shoots portraits and weddings as well. For more information, visit www.bluefoxphotography.com.

BACKGROUND

I didn't study photography in school, though it was a favorite hobby, because my father was a lifelong amateur photographer, and I grew up with a darkroom in the house. When I moved from the East Coast to Colorado in 1982, I worked at a photo studio as a front office manager and photo assistant, and eventually shot portraits as well.

After a year, that studio's business diminished and I was jobless, so I began taking photo assignments on my own. Within another year I had a full-fledged business. My journalism background, coupled with service and sales experience, helped me approach photography and people from a "lifestyle" perspective, before the term was coined. I was always interested in telling a story with my images.

TRANSITIONING TO COMMERCIAL WORK

My career began with a focus on family and wedding portraiture, and I occasionally accepted other assignments to help pay the bills. In recent years, more and more people have moved away from hiring portrait photographers and are doing their own kids' and sen-

ior portraits. In response to this trend and to fill up our shooting schedule, I have moved toward taking on commercial jobs, photographing corporate executives, and shooting events such as meetings.

Colorado Springs Business Journal, which has helped stimulate our commercial market, especially executive portraiture.

ABOUT THE STUDIO

Ours is a "boutique style" studio in an 1800-square-foot cottage located on a primary thoroughfare that leads directly to the downtown business sector of Colorado Springs. The neighborhood is a mixture of business and residential properties and is situated on the edge of an area filled with white-collar, professional residents. These people represent the majority of my clients, for both private and commercial work.

The studio has a reception area, a sales and office area, a camera room, dressing rooms, a production area, and a framing room in a small, finished basement. The space works, but I often feel we could use more room. I have one full-time office manager, plus four other part-time employees who cover postproduction work, framing, business, and accounting needs—and occasionally do some shooting. Our team

With my longtime photographic background, making the switch to commercial work was relatively easy. I've added new lenses, but I generally still work with gear I've had for a while. We advertise weekly in the

is pretty flexible because they have been cross trained, so we are covered in the event of illness and time off.

VARIED SPECIALTIES

We focus primarily on photographing executives, offices, events, corporate promotional, and creating images for our clients' advertising needs. We do some product work and are expanding our services. We have experience with most types of commercial work except aerial and architectural, both of which require specialized equipment and a unique skill set.

Our location work focuses mainly on photographing office interiors. We schedule these shoots during daylight hours to make use of natural light. Shooting midday, when the sun is directly overhead, works for us. Either we get great, nondirectional ambient fill or we make the best use of existing light and bounce strobe fill into the shadows.

With executive portraiture, our goal is to give subjects our full attention, to limit the time it takes to get the shot, and to produce high-quality images. We're careful to work around common problems like bald spots, glare from glasses, impatience, and some people's extra weight.

PRODUCTS, PORTRAITS, EVENTS, AND WORKSPACES

Product photography—usually small objects and art pieces—is nicely accommodated in our medium-size studio. We use a standard studio lighting setup (described below). Our clients' products don't require sets, but we do use custom-made platforms for many products. When working on location at our clients' offices and work spaces, we bring a portable lighting system, plus a frame and background if we're shooting portraits.

For product photography, creating a smooth lighting effect without too many specular highlights is a necessity. Keeping the colors of products "true" in the image is important and can be difficult.

I have experimented with a variety of lighting arrangements. Sometimes side light seems to work best. Of course, I love reflected light from an umbrella for many applications, because of its soft, wraparound nature—and it's great for main light or fill—and sometimes both together.

Clients often want staff portraits and images of interiors and workstations for use in their marketing materials, on their web sites, and for general publicity. I use ambient reflected light for portraits when I can.

My favorite work is photographing events. I love capturing a large group of people united in shared moments. At corporate events, the challenges include gathering the necessary groups of sponsors, committees, and VIPs; adequately showing very large venue interiors; and quick turnaround of image files to meet media needs. It can be tricky to light interiors without reflections, odd shadows, or glare. I usually bring an assistant to event sessions to facilitate setting up, composing groups, and running errands.

OUR LIGHTING SYSTEMS

We use Bowens and Photogenics lighting systems with umbrellas and a 3x4-foot softbox. These systems accommodate four flash heads. We also use a small Novatron travel lighting system and use one or two heads for hair lights. For extra light accents, we use a variety of reflectors in and out of the studio. Our reflector collection, which includes white, silver, gold, and a pink/silver checkerboard modifier, allows us to create a range of lighting effects and patterns.

CAMERA EQUIPMENT

I shoot with a Canon 5D and use a Canon Rebel XTi as a backup camera. My staff shoots Nikon. We like

mid-range lenses such as a 28–135mm for most work; we also use a fisheye lens for some architectural shots. For studio portraits, we use a 70–200mm zoom lens. We do not tether a camera to a monitor at this point but may in the future so the photographer and clients can view the images immediately.

DEALING WITH CLIENTS

Before you start a job, the client should inform you about how the photographs will be used and share their creative concepts and expectations. You can then make preparations on scheduling. We also discuss art direction items such as clothing and personal effects, turnaround time, refund policies, satisfaction guarantees, cancellation policies, etc. Most of our protocol is documented in our brochures and paperwork. At the studio, we make clients comfortable with soda and candy, and we offer them private areas where they can take calls and complete paperwork.

During studio meetings or before, we receive credit card payment for the shoot. If for some reason we aren't paid before the shoot, we ask for credit card payment immediately after the shoot. If you send a bill after a shoot, you may not be paid for thirty to ninety days, which makes it difficult to run a small business and pay bills on time.

POSTPRODUCTION

I do my own image editing, though I am assisted at times by an experienced staff member. Most other postproduction is done by our staff digital expert using Photoshop. Occasionally, images need time and attention at a pro lab where our printing is also done.

PRICING

We price at the mid- to high end of our market without being the highest price in the region. Generally, my commercial time is priced at $300 to $400 per hour, including image ownership. Sometimes we must negotiate our prices to be competitive. My staff shooters are priced in the $250 to $350 per hour range.

Private client portrait sessions run a basic $189 to $329, depending on how long a session lasts and whether it's in the studio or on location. All reprints are priced separately: 8x10s are $89, 5x7s are $59, 4x5s are $29, and larger wall prints are $179 to $799. We offer no packages. We do run specials once or twice a year, when all session and reprint prices are cut in half. Obviously, we offer bargains when business is slow. Our average sale is about $1200 gross.

COPYRIGHT PROTECTION

Our commercial work, including executive portraits, has always been sold with a copyright attached. Most businesses want universal rights to use the images as they wish, and we price the work high enough to allow this freedom of use. Our release form, which ensures clients of their right to full usage, accompanies the CD/DVD of their images.

We retain the rights to our portrait and wedding work. All prints have copyright information on the back. Clients are advised through paperwork that no unauthorized print reproductions are permitted. Occasionally, we sell the rights to private sector images, especially after twelve to twenty-four months.

The rights situation is changing. More people are requesting outright ownership of portrait and wedding images, and more often then not, we tend to oblige them. In such cases, we increase the final price to reflect the full reprint profit we can anticipate, though we are still refining our policies about when and how we will sell full rights. How much must the minimum order be before we sell all rights? Are there consequences we might face for not having control over how our images are reproduced? We would require that we could freely use the images for advertising and promotional purposes. For the right price there are advantages financially for shooting, burning, and delivering portraits. Certain overhead is eliminated, but is it in our best interest, or the client's? We're making limited experiments.

Actually, I think selling full rights is where the industry is headed, and we will need to stay competitive to remain in business. This trend is definitely fueled by public demand. However, when clients buy ownership of their images, we emphasize that we are still a professional resource to provide support, guidance, and Photoshop services on request.

A BUSINESS PLAN

I've never had a strict, written business plan, but I have formulated goals to achieve, often new ones yearly. Early on my goal was to be one of the top three photographers in my region. I set about following good business habits, which was critical, and I achieved my goal. Ten years into my business, my goal was to own my own shop, and I went about making that happen. In 2008, my goal was to redesign my four-year-old web site and to develop my book concepts. The books are still a work in progress, but my revamped web site has been launched.

A FINANCIAL SUPPORT TEAM

I have an accountant and a bookkeeper. I review my business figures almost weekly and decide what we need to do to tweak receivables and expenditures. I compare past years' figures with my bookkeeper monthly. To stay on track, I have the facts I need to make necessary business corrections.

My accountant and I meet once or twice a year. He's not as creative as I'd like, but he keeps me honest and safe. I am at a point where I want a financial advisor who is familiar with my industry to help me direct investments and other financial actions. This is my goal for this year!

TIME OFF

I need regular time off, and I tend to schedule most of it during the slow first quarter of the year. I have a front-office assistant and competent staff who function smoothly while I'm gone, but I try to be available for serious questions. We don't close the studio, except for holidays, and we fill in for each other so we all get breaks.

MARKETING

I enjoy the process of advertising and marketing, which allows me to engage with services that directly influence our business. My original approach to retaining one satisfied client to generate referrals has grown into pleasing numerous clients. When they have good experiences in our studio or on location, they tell friends—some of whom contact us and help keep us busy.

In the beginning I used creative low- or no-cost marketing such as donating packages to high-end fund-raisers, volunteering for nonprofit needs, and joining women's business clubs. I'd put fliers on cars, in business windows, and around town. My postcards were everywhere, making my business highly visible. I also began low-cost advertising in local newspapers, women's bulletins, and radio specials.

Wherever possible, I try to create a trade relationship, providing photography in exchange for advertising on TV and in publications. Increasingly, however, the Web is the place to be seen. We have a new web site as well as a Facebook page to reach more of the younger audience. We always ask how our clients heard about the studio. Though in the past, the answers to that question were more diverse, we now find that more and more clients find our web site through Internet searches.

PERSONAL PROJECTS

I'm working on a book, *Dogs of Mexico* (working title). It's planned as a coffee-table book presenting glimpses of Mexico through the eyes of its dogs. It's not pathetic, it's whimsical. I hope to partner with a Mexican rescue mission, and I'll donate a portion of the proceeds to help homeless and abused Mexican dogs.

Another book project is about West Highland white terriers. After adopting a Westie puppy three years ago, I realized there are no picture books about the cutest breed on the planet, so I'm creating one.

INTO THE FUTURE

I'm in my mid 50s and have been running Blue Fox studio for twenty-five years. When I feel a bit worn out, I remind myself that photography is still my greatest skill and passion. I can't afford to retire completely in my early 60s, but in the future I'd like to do some freelance work and may volunteer for worthy causes. I envision doing more books and probably continuing high-end portraiture. Perhaps I will hand off more work to my younger associates. At some point, I may sell my business and operate independently under my own name. Luckily, an artist has many options!

ORGANIZATION MEMBERSHIP

I have belonged to the local chamber of commerce, convention and business center, business and women's networking groups, as well as being on committees and boards for nonprofits. All these helped widen my circle of friends, associates, and clients. At this point, I'm a little too involved and am taking a break. I read professional publications and belong to several national photographic groups, but I have less time and energy to participate. I am constantly observing advertising styles to get ideas for future work.

PHOTOGRAPHER'S PERSONALITY

I believe that a professional photographer's personality has great bearing on his or her success. A pleasant, positive demeanor is a primary asset. Your clients can't help but be won over by a sunny, warm, helpful, creative, "can do" disposition. If they feel good about their experience with your business, they will tell others and become lifelong supporters. This has been a staple in our studio's success. People genuinely like us!

4. DOUG EDMUNDS

During his senior year at the University of Wisconsin–Madison, heading for a degree in art education, Doug Edmunds bought his first SLR with a 20mm lens to record a sculpture he installed in an exhibition. In the years following, his passion for photography flourished, and his equipment inventory grew. He resigned from a position as a middle-school art teacher to pursue an art career and started selling silk-screened t-shirts. Photography added to his income and became his profession. He has owned photography studios in his hometown of Madison, WI, as well as in Los Angeles, New York City, and finally his present studio, located in Cedarburg, WI. For more information, visit Doug's web site at www .edmundsstudios.com.

THE LEARNING CURVE

I've never formally studied photography. For me, the process or creating images was fulfilling enough to offset technical hurdles and snags. Eventually, by reading, trial and error, and honing my vision, I got pretty good at doing black & white work, and learning color came all too soon.

My leap into true commercial work meant I must perform on cue with an art director overseeing me. Because I was always shooting something new, every day was educational. Now those days of mind-numb-

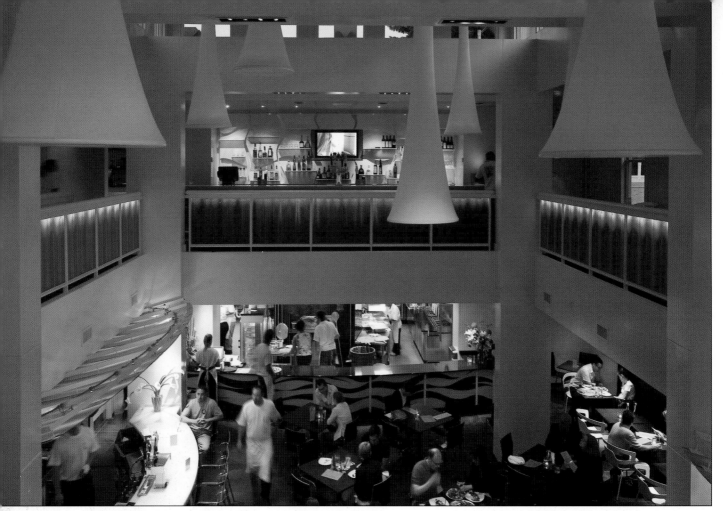

ing improvisation seem so distant. Today there isn't much that can freak me out.

MY FOUR BASICS

Commercial photography requires expertise in these four basics, each with subcategories: (1) technical skill, (2) finding the work, (3) shooting the jobs, and (4) getting paid. While navigating the process, you hope to maintain your artistic sense of accomplishment, which can be a tall order.

FIRST COMMERCIAL JOBS

I resigned from teaching and began taking portraits in Madison. I did sessions and had an exhibition. The images were tight head-and-shoulders shots against a white backdrop, loosely based on portraits by Richard Avedon. My exhibition was a hit and drew interest from an advertising agency, for which I shot testimonial ads for a local business. Those pictures formed the foundation of my commercial portfolio.

My next major commercial job was an annual report for Sentry Insurance. Working with their agency was challenging. I learned how to hire assistants, how to price myself, and how to deal with an art director's instructions. I survived an environment I'd never experienced and worked for this agency for many years. I continued to learn on the job. It could be scary, but it was exciting. I shot in all kinds of weather, in large industrial areas, doing close-up product details, landscapes, interiors, and photographing people at work. I traveled widely and often shot with client instructions and no art director. I discovered how to think conceptually.

MY CURRENT STUDIO

My studio is located in Cedarburg, WI, in a 2000-square-foot space with a central 800-square-foot shooting bay. My wife Teri and I each have offices, and there's a gallery/client area.

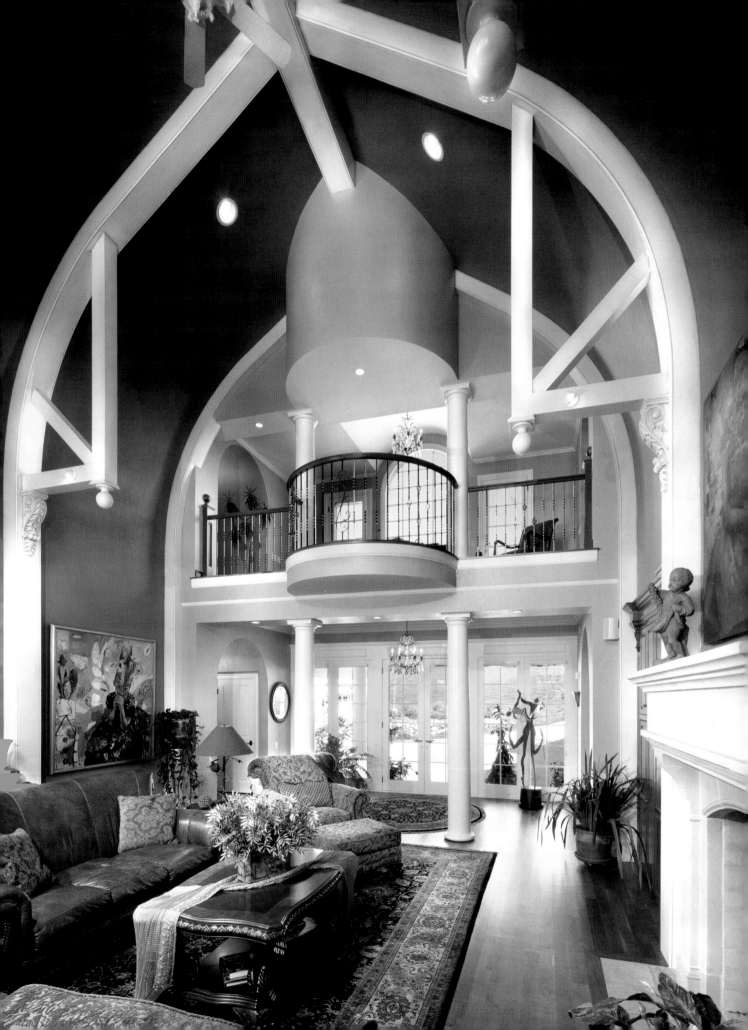

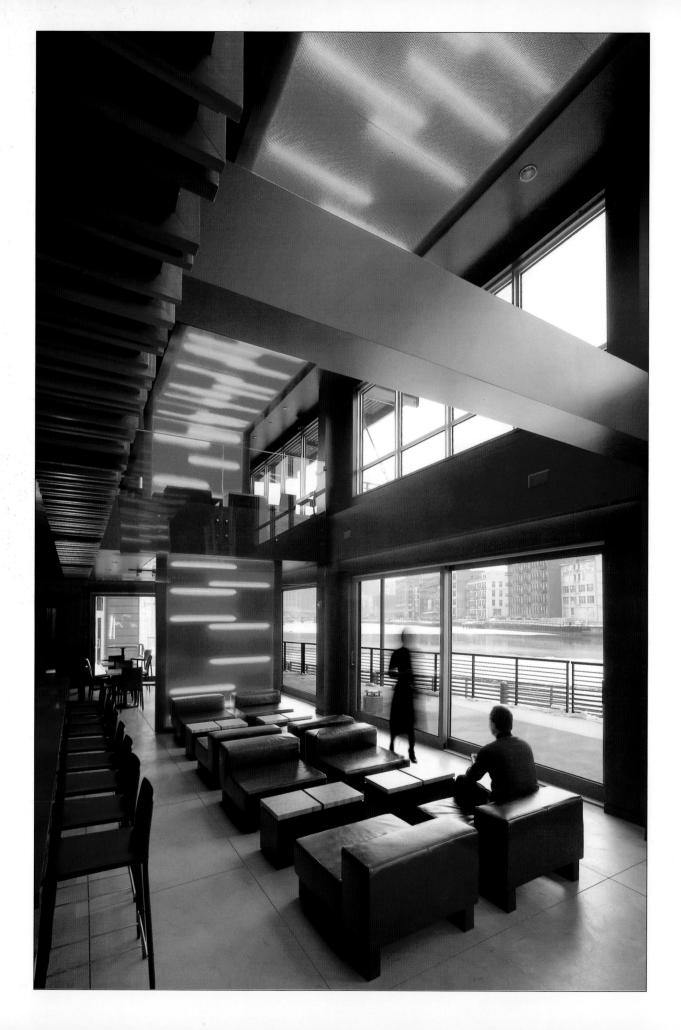

I can rearrange the shooting area quickly to fit various jobs. My Mac laptop is on a rolling table and can be moved easily when shooting fashion or action.

GEAR

Camera Equipment

- The Canon Mark II is my camera of choice for 90 percent of my architectural work, most of it for magazines. The other 10 percent of the time I use a Hasselblad H1 with a Phase One P25 back—especially for night shots, distant scenes with a lot of detail, and extra-long exposures. These cameras are almost always on a tripod.
- Canon lenses: 16–35mm f/2.8 EF L, 24mm TS-E, 24–105mm f/4 L IS, and 70–200mm f/2.8 L IS
- Hasselblad lenses: 35mm, 50–100mm zoom, 150mm
- Pelican waterproof storage case
- Bogen Salon studio camera stand with an Arca Swiss B1 ball head
- Gitzo 1320 tripod

Lighting Equipment

- Speedotron 2400 and 4800 watt-second power packs with four flash heads
- Elinchrom mono strobes of 300, 600, and 1200 watt-seconds
- Bowens 300 watt-second mono spot
- 10-, 20-, 30-, and 40 degree grids that fit both studio strobe brands
- Lumedyne portable 800 watt-second strobe system with Quantum Q flash head
- Canon 580 EX strobe
- Five PocketWizard transceivers
- Large, medium, and small Chimera and Photoflex softboxes
- Large and medium Photoflex half-dome softboxes
- Umbrellas of various sizes with white linings

Set Essentials

- Saw horses, apple boxes, supports
- Custom-made, pulley-operated backdrop system
- Custom-made 10x20-foot painted muslin backdrops

- Basic white, gray, and black backdrop paper mounted to individual aluminum poles
- Foam boards, Gator board, plywood, sheets of Plexiglas

Computers, Image Editing Tools, and Printers
- Two MacBook Pro Core Duo (OS X) laptop computers (15-inch and 17-inch)
- Two Mac Pro Quad Core (OS X) computers with 23-inch Apple cinema displays
- Wacom Intuos 3 graphics tablet
- Adobe Photoshop CS3
- Capture One Pro software
- Epson 9800 inkjet printer (44 inches wide)

ASSISTANTS
Most of my shooting is on location, and I often hire assistants I have personally trained. Those who have studied photography take as much time to train as someone with no formal background. Studying art and photo history without enough practical studio lighting and shooting experience is not usually adequate for commercial work.

LIGHTING TECHNIQUES
Lighting is the major issue in highly successful images. I love available light, outdoors or in factory situations. Whatever auxiliary lighting I use should not look artificial. Lighting augments the composition by creating separation of objects from each other and by enhancing their surroundings. Light establishes mood and leads viewers' eyes to the visual message.

In interiors, you might use daylight from windows along with warm tungsten fixtures. Sometimes tungsten lighting alone or in combination with strobe is useful. Digital allows me to light different portions of an interior in separate exposures and layer them together later. Without moving the camera, a number of identical shots are taken with special attention to lighting and camera exposures to show off different areas of a room—one exposure for windows, another for the fireplace area, another for a general area, one for the light fixtures and lamp shades, etc. In postproduction, the color will be balanced, and the segments can be cut and pasted into the main shot.

When photographing products, still life, and people on sets, three lights are usually required: a main light, a fill light, and an accent light. For smaller product work, a main softbox in conjunction with a fill light might be enough. Products with unique shapes, textures, and reflective surfaces require special treatment, often using reflectors. With a camera digitally tethered to a computer, you can follow changes in lighting and composition on a monitor.

LOCATION CASE HISTORY
I recall a location job requiring extensive planning and execution. It was a national ad campaign for Karastan Carpeting. I located a specific stylish home to show off rugs and carpeting, and we used it for a week. The head art director, corporate marketing personnel, etc., were involved. The home was completely refurnished, and certain shots required hiring models. My Hasselblad with a digital back and a 35mm lens, tethered to my MacBook Pro, made the shoot possible.

We shot from 8:00AM until sunset. I used two assistants, and crews prepared the rooms to meet our

shoot schedule. On-the-spot photo problem solving was constant, and we alternated vacating rooms while waiting for a video crew doing commercials. I did postproduction work at night, and image samples were ready the next morning. Low-resolution versions were e-mailed to corporate headquarters in Georgia. A national advertising campaign generates high-pressure work to produce top-notch images.

DIGITAL WORKFLOW

I shoot RAW files, which require conversion before output is possible. RAW provides the ultimate digital quality. The pitfall is the tendency to get lazy while shooting and assuming corrections can be made later on. Digital has a built-in, flexible safety net but requires common sense. With proper shooting skills and software, photographers can produce images that once upon a time would have been impossible.

Typically I edit all the shots and deliver only the best. I inform clients how I work, and they welcome my approach, knowing they get the bulk of the shoot. My Epson 9800 inkjet printer makes tack-sharp, vivid color prints up to 44 inches wide and any length on a variety of surfaces. Mounting and framing in-house is a great benefit.

CLIENT RELATIONSHIPS

Most of my work is corporate, editorial portraits, and architecture, followed by industrial, products, and food. Thanks to my web site, I shoot in my region for ad agencies and magazines anywhere. Some of my national clients have been *Canadian Diamonds* magazine, Jaguar-Landrover, Mazda, Wells Fargo, Cessna

Aviation, Hearst Publications, and national trade magazines. Advertising and design assignments have waned, so shoots are generally done without an art director. Client collaboration on jobs requires people skills, patience, respect, and knowing when to stand your ground. I like to keep clients informed during a shoot; some enjoy input, and others just want to get the job done.

I never make excuses for finished work because whining while making a presentation is just not cool. The client is interested in the product, not the process. In most circumstances, an artistic temperament is counterproductive. I think of it as attitude.

CREATIVE INSPIRATION

I'm a fool for a good idea. With ego out of the equation, other peoples' ideas can be very welcome. This applies to my assistants, clients, and their employees. I study pictures in print ads, posters, billboards, coffee-table books, magazines, brochures, postcards, old (and newer) family portraits, and historical images. I also get inspiration from studying paintings and sculpture. Talent is a precious commodity, and I've come to understand there are people who are far more experienced and talented than I am.

It is good business to be needed and appreciated, wherever it comes from. Staying in business for over thirty years has demanded flexibility in order to bounce back from failure. Especially in the earlier years, passion, perseverance, and talent carried me. Perhaps more important were an incredible wife and deep faith.

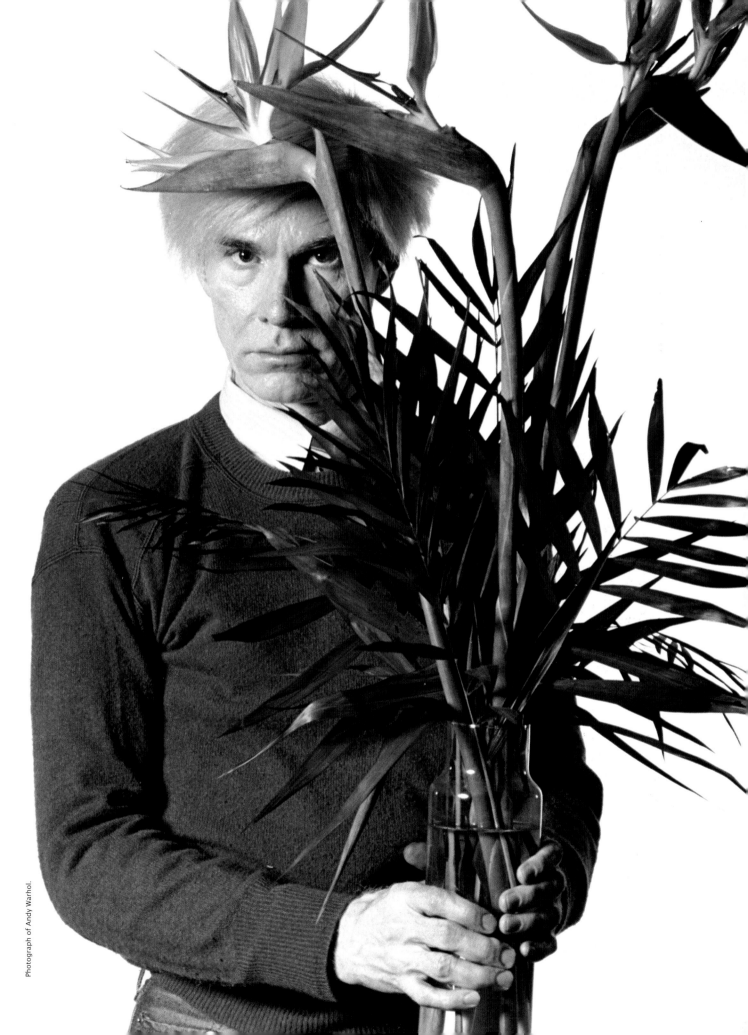

SETTING FEES

There are a number of questions I ask potential clients that help me determine what I will charge for each job. These questions, plus some other strategies for setting fees, appear below:

1. Regarding the job: what, where, who, and by when?
2. How will the images be used? *(Note:* The more valuable pictures are to a buyer, the higher the fee you may ask. Advertising space charges are based on magazine and newspaper circulation. Annual reports are very important to corporations, so high day rates are common.)
3. When clients ask how much I charge, I counter with, "What's your budget for this job?" or "What have you been paying for similar jobs?" I can negotiate with confidence knowing what they have paid and can often command a higher price when I know what they anticipate paying.
4. You might also point out your experience and efficiency.
5. Advertising jobs and some other commercial jobs may command higher fees than those charged for editorial work. The fee for unlimited use is usually built into my negotiated price.

When you are starting out, contact more experienced photographers about their pricing strategies. Many will tell you what they charge because they don't wish to be undercut.

In negotiations, both sides need to feel they have won. Educate yourself in the art of negotiation. *The Real Business of Photography* by Richard Weisgrau (Allworth Press, 2004) includes a very useful chapter on negotiating with clients.

COPYRIGHT ISSUES

The moment you take a picture, you own the copyright—unless you have a different agreement. You

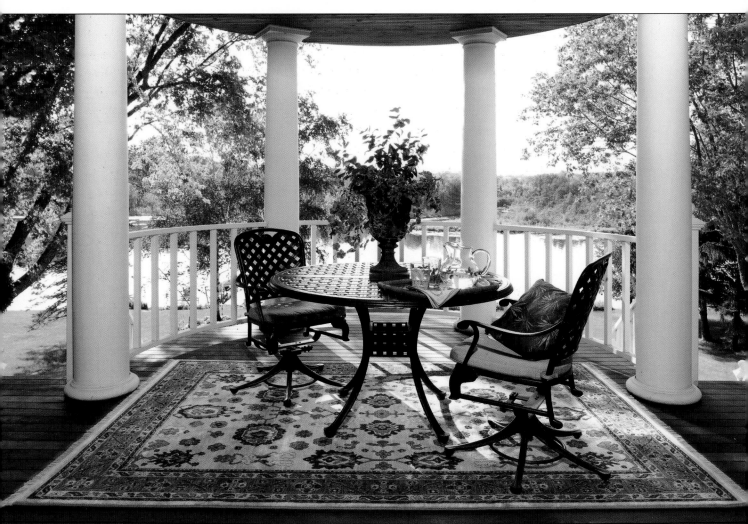

lease rights to the photo but retain ownership. Clients with experience understand copyright and usage fees; those who ignore your rights need to be educated.

It makes sense to register your pictures with the U.S. Copyright office. This can be done in bulk via mail or online. Indicate your copyright on the back of your prints or ensure that the information is imbedded in your digital images. If you register your copyright and there is an infringement, you can be awarded $10,000 or more if infringement is proven in a court action.

Your agreements should cover not only your fees and an estimate of expenses, but also an explanation of the usage rights. Advertising and design companies typically want usage spelled out, so it's rare that I've been unable to negotiate a favorable contract. Most formally signed contracts are initiated by the client rather than me. I make out a detailed quote, and they look it over and transfer our verbal agreement (per my quote) to a written agreement.

STOCK IMAGES

Stock images are a big part of my business. Prints for display or portfolios are billed for the cost of the print only—no commercial usage allowed. Web use, brochures, ads, and other applications are billed at an appropriate rate depending on the type of client and the duration of use. All my consumer portraiture has a blanket copyright and is strictly enforced. I am assisted in this by the commercial print-finishing industry, which firmly refuses to print anything without my studio's permission.

BUSINESS DETAILS

My business has expanded mainly to service our client base. Our web site is the main marketing tool, and an-

other is regular contributions to a monthly publication that displays my work.

We have a professional accountant who takes care of tax returns. My wife handles all the business-related tasks. Teri and I each draw a salary, and we have been setting aside income against slow periods. Earmarking monies for investment was a smart move, especially in the hands of a professional firm.

We try to get away for an uninterrupted week during the year, and we take days off or come to work late and leave early when possible. Monitoring two teenage daughters and their schedules is part of our lives.

Commercial photography is a creative business, like other photographic disciplines, and it's as rewarding as the effort you put into it.

5. GARY HARTMAN

Gary has been shooting since he was about six years old and was in all the audio–visual clubs while growing up. His first professional photography job was running AV presentations for U.S. Industries, a land development company that had a sales technique using multi-screen 35mm slides and 16mm film. He received a degree in radio, television, and film from the University of Texas–Austin in 1977. He lives in San Antonio, TX. You can visit Gary's web site at www.garyhartman photo.com for more information.

EARLY EXPERIENCE

Having a diverse employment background and skill set will help you later in developing your attitude and photographic style. I did everything from pizza delivery to pumping gas and was encouraged to find something I enjoyed doing. Working for PBS as a film-chain photographer for a production called *Caboodle*, a children's art education program, was a very good experience. I also had a stint as a photo technician in a work-study program at the McDonald Observatory.

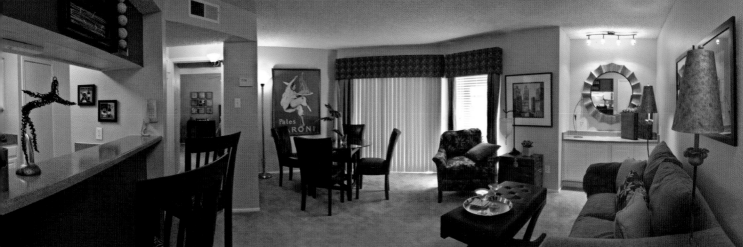

After various job interruptions, I moved to San Antonio to work as a police photographer for the regional crime lab. This was before the TV show *CSI* made it cool. There was a lot of blood and guts, but documentary illustration was an invaluable experience. I eventually became department head of the Public Information Office for the City of San Antonio. I had to write most of the time and did photography about a third of the time. It didn't feel right. After about six months, I decided to strike out on my own. I had made my acquaintance with a number of good—and I hoped, steady—clients, stocked up on equipment and supplies I could afford, and saved enough to live on for four months. In September 1980, Gary Hartman Photography was inaugurated. I worked out of my house for the first three months until I could afford separate office space.

STARTING YOUR BUSINESS

Starting a business is scary. There's more risk in self-employment because many people feel that a professional photographer is just someone who takes a lot of pictures because it is a glamorous thing to do.

Being proactive will help you to make your dreams come true. You will find that education, both formal and hands-on, will help you to earn respect as a professional. You will boost your confidence and make professional connections at every shoot. You'll also find that making the acquaintance of other professionals can help. Many people over the years have shared bits of wisdom about what's expected of a photographer. Most of what I recall was a mixture of good and bad advice.

SPECIALIZATION

At first, it's hard not to be a generalist and take the jobs that come along, especially since the opportunities can provide valuable experience. Some jobs that just "happen" may lead you into types of photography you like a lot, and you may find a specialty. On

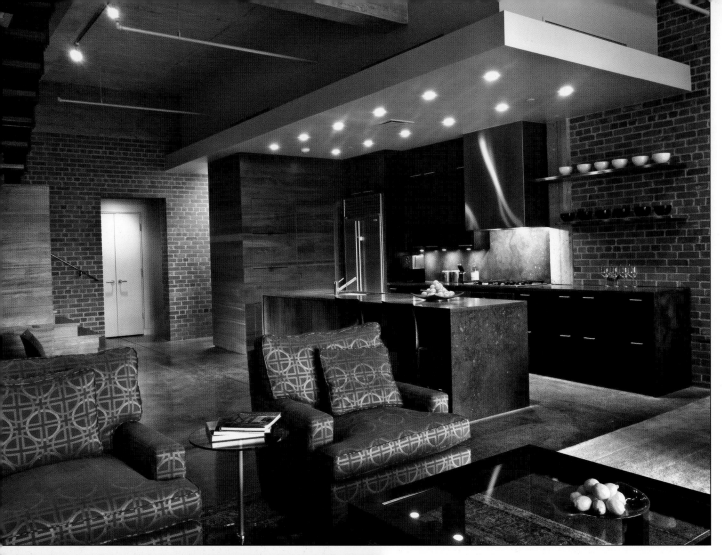

the other hand, you may just gravitate toward a commercial category such as products, interiors, events, artistic wall images, corporate portraiture, or scientific and forensic work.

My photographic focus has changed over the past twenty-seven years. Initially, I earned a reputation as a pretty good product illustrator, and I've since done a lot of interior and architectural photography. Since the advent of digital, I've become a bit more of a Photoshop manipulator. Today I concentrate on architectural location illustration; however, I don't see myself as an illustration photographer—I'm more of a photo engineer.

MY STUDIO

For the first nineteen years I had a 2500-square-foot studio, which was pretty large for my market. There was shooting space, a separate office, a client comfort

and entertainment room, a dressing room, and a small kitchen (actually, just a stove and a sink because I didn't do much food photography). I shot with cameras ranging from a 35mm Canon to an 8x10 Super Combo. I had about 8000 watt-seconds of strobe and 6000 watts of hot lights, as well as booms, backgrounds, and still-life surfaces—most acquired or built to meet my clients' needs. I also had to tweak or modify some of my equipment to meet my own needs.

Since going digital, I've pared things down some. For the past five years, I have rented studio space when I needed it, but most of my work is shot on location.

CAMERA GEAR

Since making the switch to digital, my camera choices have changed. I now use three Olympus kits—two E3s and one E1—and four very sharp Olympus lenses

ranging from 14mm to 600mm. Each kit is transported in its own lightweight backpack.

When working on location, I usually try to find out how the client envisions the subject(s), and I choose lens focal lengths to achieve various workable professional images. I feel that my job isn't necessarily to create my own ideas, but to realize and shoot the client's mental visions as well.

LIGHTING EQUIPMENT

I use ambient light as often as possible, blending it with supplementary color-balanced hot lights. My work runs the gamut from small jewelry shoots to large products. With digital technology, except for on large architectural jobs, I don't need the light power I used with film.

The largest product I've had the pleasure of lighting was a special road resurfacer, about twenty-three feet square and 15 feet high. I shot it at the company warehouse with a seamless white cove built around it. I lit it with one large softbox overhead on a boom as a main light, two other softboxes at the front sides, and six background lights. Photographing two different road resurfacers took five days.

When you have the opportunity to light a subject, it may be hard to separate creative composition from creative lighting. They complement or detract from each other. I have two lighting rules: (1) Start out with a high 45-degree light and another 45-degree light to one side and build from there. (2) Rule one may not always work. Start out with what you know, then develop it into what you want—and don't be afraid to start over (time permitting). Get to know your lights regardless of what brand, quality, or quantity, and get to know them *well*.

LOCATION LIGHTING

The ambient light you find at any location, and the light you'll need to provide, will vary from place to place and from subject to subject. As such, you can only guess what you're going to be up against. That is why a location scout comes in handy. I've called on other photographers I knew in other cities to investigate a location for me. I always pay my scout, and their fee is included in expenses I bill for.

Overall, working with digital capture allows you to travel lighter when working on location. Lightweight, slaved on-camera flashes with remote radio triggers and maybe one or two hot lights may be enough in some situations. However, if you have the vehicle space, taking more is better than less.

SHOOTING REFLECTIVE OBJECTS

One of the toughest and most enjoyable ongoing projects I've had was photographing various brands of beer cans and bottles. Lighting reflective objects that have been sprayed with water without causing hot spots or creating a reflection of the camera on the product can prove to be a challenge.

To create the set, I constructed a foam core enclosure about four feet high and eight feet wide on three sides. The fourth side was seamless white paper, and I could crawl into the setup on one edge of it. In the center of the front foam core wall, I cut a hole just wide enough for the front element of a Komura 210mm lens on a 4x5 view camera, and I photographed using chrome film.

Here's the fun part: Inside the enclosure, 2-foot tall sheets of foam core along the inside wall of this enclosure were positioned about a foot away from the walls at a slight angle away from the center. Strobe lights were placed between the walls and the half foam core sheets, aimed at the outer walls. The light bounced softly and did not reflect off of the cans or bottles.

I crawled across the floor to spray the can or bottle, holding a cable release to make exposures when the drips and beads of "sweat" were right. Thank goodness for Photoshop!

PHOTOGRAPHING SMALL OBJECTS

Though the set I use to photograph reflective objects is pretty intricate, jewelry sets can be much more complicated. I found myself crawling on the floor a lot in the studio. I prefer to construct a set a few feet off the floor on risers and crawl around it on blankets and pillows so I don't have to stand over a waist-level set and rack my back leaning over it. For jewelry and small objects, I use a tent of usually translucent cloth that blocks reflections and passes light evenly and with soft shadows on what I'm photographing. Slim reflections can be created on metal surfaces by using small light sources inserted through slots in the tent. Tents of various sizes are available from photo supply stores.

USING AN ASSISTANT

Brainstorming and relying on the assistance of location scouts are very important parts of preparing for a session. I usually work alone or with one assistant; however, when jobs are larger and more complex I

may use two assistants. Often these assistants are a hired electrician or construction worker(s), makeup artist, stylist, or a regular grip. A crew may be comprised of ten to fifteen specialists. The largest crew I ever had was twenty-two, when we constructed a three-walled hotel room for the client, La Quinta. The session took place in the studio, and I shot mostly from the loft above into the room set below.

COMMUNICATING WITH CLIENTS

It is necessary when dealing with a client, especially a new one, to ascertain his attitude and sophistication about photographers' rights. I ask about the usage terms the client is looking for. If they are surprised about the question, I know I have to express the need for open communication. I explain that the broader the usage rights they need, the higher the fee, because they get what they pay for. I also explain that I am trying to produce for them the greatest revenue potential with my pictures, and by working together, we can succeed.

An experienced and sophisticated client in most cases will appreciate my efforts and will negotiate a fee that covers the time interval for which he wants to use the photographs. There is an advantage in dealing with corporate buyers and advertising people in that I expect they will know about usage rights and understand the time and effort it takes to accomplish some of what they ask for. The size of the client's budget is also a determining factor when quoting fees.

PRICING PHOTOGRAPHY

I charge clients for three things: production costs, creative fees (if there is no art direction and they are expecting me to handle the creative aspects or concepts to be produced), and usage fees. My quotes and invoices do not always refer to these components, but that is how I set my fee.

It isn't always worth spending the extra time necessary to bring some people up to speed, especially about aspects of licensing images and copyright matters. Unfortunately, these can be the deal breakers when a company wants more usage rights than it

wishes to pay for. However, when a client wants all rights—including copyright—I might triple the fee to make an arrangement that includes future sale potential.

My copyright notice is on everything, many times inconspicuously on the back of prints or in the EXIF files, but everything possible has a legal notice stating usage time.

POSTPRODUCTION WORK

All postproduction work is done through my studio. Postproduction can make or break an image. It definitely affects the subtle character of some images, and for commercial work—especially advertising—it seems essential. Improvements can run from simple enhancement of the sky, to changing the view through a model home's windows, to fully furnishing a house by superimposing elements of rooms shot elsewhere. It's amazing how such changes improve the dynamics of an architectural image. An extensive knowledge of Photoshop and other editing tools can take years to acquire, but understanding the programs will definitely facilitate your communications with professionals who supply postproduction services.

A BUSINESS PLAN

It is very important to have a business plan, even if it is just a wishful attempt at predicting the future and how you plan to reach your goals. You need something tangible as a reference that you can contemplate. Plans usually change, both in content and in the method of producing them, but having a record of your goals during your business life is essential, especially in the beginning.

USING AN ACCOUNTANT

I have an accountant, but I try to keep him on the sidelines. I like to keep track of what is going on, with an educated professional to guide me. Finding a good one may be difficult, so get a recommendation from a successful friend.

TIME OFF

I usually try to schedule a vacation to coincide with what may be a slack period. I'm a single parent of a thirteen-year-old kid, and I guess priorities change. I used to take many more vacations than I do now be-

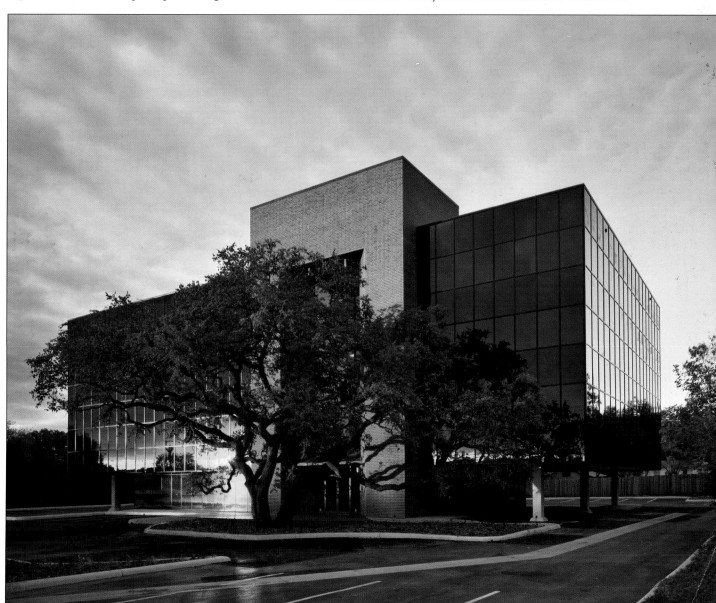

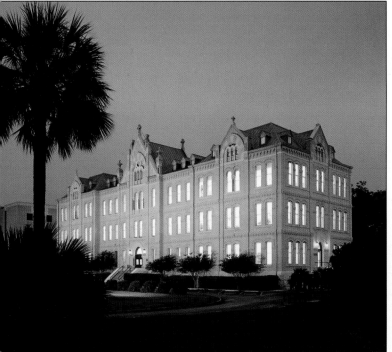

cause when I'm gone the business shuts down, except for e-mail and cell phone connections. I think my vacation schedule is fair to me and to my clients, who are notified about upcoming vacation time.

REFERRALS AND PROMOTIONS

I used to do postcard campaigns, and they were somewhat effective, depending on their design and timing plus the printing and mailing list costs. Word-of-mouth referrals seem to be the most effective means of generating business. Other means of promotion include Yellow Pages ads, your web site, search engine optimization (SEO), networking at social functions where clients may be, and bylines on written articles.

BUSINESS ACTIVITIES

I have belonged to ASMP (American Society of Media Photographers) for more than twenty years. The organization provides a lot of useful information on protecting your rights and offers a lot of important data in its publications. There are a number of helpful organizations in the business field, both locally and nationally. Seminars can help to keep you abreast of techniques and hardware you need, and attending photographic conventions is a great way to continue to educate yourself.

When your photography will be published, it can be helpful to refer to the ASMP's *Professional Business Practices in Photography* (7th ed.), which was published in late 2008. It's a comprehensive resource. You can check it out at Allworth Publishing's web site (www.allworthpublishing.com).

THE ROLE OF PERSONALITY

A great personality can be an invaluable asset. I had a very wise professor at UT tell me that half of what makes one a good photographer is good people skills, and I've found it absolutely true.

6. TODD QUOM

Todd's photography experience started in high school. He didn't study it there but he owned a 35mm Minolta and shot scenics around southern Minnesota where he grew up. Somewhat later, while working for AT&T in Phoenix, AZ, he won several company photo contests. His seventeen-year career with AT&T gave him marketing experience, which he eventually used in his own business. He was confident that he could shoot saleable pictures and longed to be in complete control of customer service. Today, Todd is a busy aerial photographer based in Sacramento, CA. For more information, visit his web site at www.digitalsky.us.

BECOMING AIRBORNE

While at AT&T, my wife and I spent a year in the San Francisco Bay area and almost six years in Hawaii. Both locations increased my love for photography. My early career was influenced by an *Entrepreneur* magazine ad for a helium-filled blimp system that would carry a remote-controlled camera platform. The 18-foot blimp, tethered to a trailer via a cable, could be elevated to 500 feet, with wireless camera control from the ground through a video link. I was very impressed, but we decided not to go into business then, and spent four more years in Hawaii before moving to Sacramento in 1966 to spend six more years and start a family.

Still interested in blimp shooting, in 2001 I visited Idaho Airships in Boise, where I went on several blimp shoots with the owner. I was very excited and knew this was what I wanted to do. Months later, I purchased my own blimp system with a 50-foot telescop-

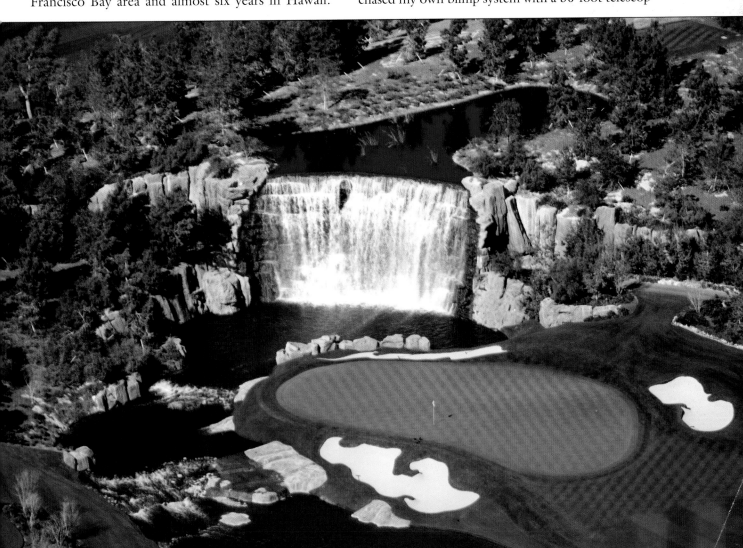

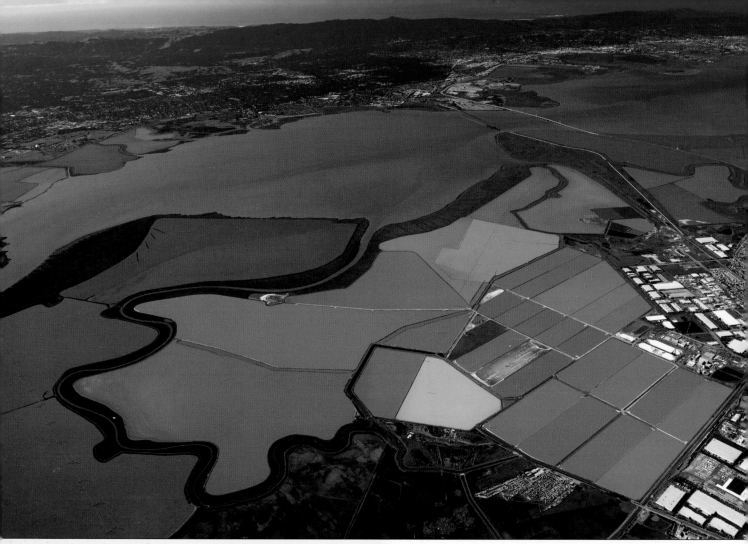

minor accidents at intersections while watching what I was doing. I was concerned about liability and eventually my blimp was sucked out of its parked trailer by a strong wind and I lost sight of it at 15,000 feet. This led me to use airplanes and helicopters for my aerial photography services.

GAINING WINGS

I discovered a Cessna flight school where instructors were willing to take a photographer on photo flights to break their routine training monotony. For four years I shot from a Cessna 172, a very popular high-wing aircraft. A pilot I flew with often, Bob Bartch, knew that 172 wing struts got in the way of my view at times, causing me to miss shots, so he purchased a Cessna Cardinal 177 that has no struts. I became his primary flight rental client, and he has become a fine team member.

ing mast and launched my company in August 2002. The blimp provided views only replicated by helicopters, but it was a distraction to motorists who caused

PHOTOGRAPHIC GEAR

As I learned aerial photography I discovered how to frame shots to suit clients. I visualized camera angles to help them sell their properties, and I developed a style to help set me apart from competitors. Currently, I carry two cameras on my lap, a Canon 1Ds MKII (16.7 megapixel) with a 24–80mm f/2.8L lens and a Canon 1D MKII (8 megapixel) with a 70–200mm f/2.8L lens. With f/2.8 lenses, I can use faster shutter speeds for sharper images if the plane bounces at 80–90 mph. Switching lenses in flight with only one camera had caused me to miss key shots, requiring another flight circle, which meant more cost in terms of time and money.

To get in closer I use the Canon 100–400mm f/5.6L lens. From 1000 feet you can almost recognize people on the ground by their shapes and clothing. Clients enjoy picking themselves out of construction-site aerials. For ground-based architectural shots, to make a room appear larger, I use a 17–35mm f/2.8 wide-angle Canon lens, and for vertical line correction I use a 24mm TSE lens.

THE RIGHT LIGHT

For a successful aerial shoot, buildings have to be seen with sun on their main façade. An eastern orientation

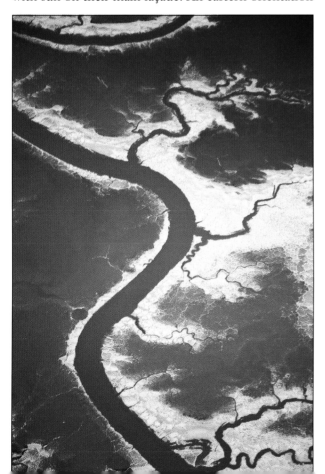

means a morning approach; I shoot western-facing buildings in the afternoon. Some clients might prefer the late-afternoon magic hour, while commercial real estate clients may want sunlight around noon with fewer shadows. I know an aerial photographer who collects ten or twelve customer projects, then shoots them all on the same flight, no matter which way they face. Some clients lose out because not all buildings are lit properly on a single morning or afternoon.

CLIENTS AND LOCATIONS

Starting in business, I decided I would only pursue customers who required repeat jobs, unlike one-time homeowners. So I approached construction companies, developers, engineering and commercial real estate firms—now the bulk of my business, with commercial real estate being about 50 percent.

California photo shoot, the Denver company was impressed enough to give me assignments in other areas. When clients are confident that you understand their needs and can do the job efficiently, they are not concerned with expenses.

I had a long relationship with the nation's top sales office for CB Richard Ellis, a commercial real estate firm located in Sacramento. They were impressed with both my aerial and ground-based architectural photography and hired me to shoot property they sold anywhere. My consistency and quality made them feel comfortable compared to their previous photographic experiences.

I travel to Los Angeles once a month to photograph ongoing aerials and ground-based pictures for a Texas client. Poor performance by an LA photographer led them to my web site a few years ago.

GROUND-BASED JOBS

There is a large market for commercial real estate architectural photos, which I often combine in a package with aerials of the same sites. Most such firms do

I have completed aerial photography assignments in nearly every major West Coast city from Denver, to Seattle, to San Diego, since a major client based in Denver, for instance, may have offices in northern and southern California as well. These firms use a wide variety of aerial photographers and are sometimes not pleased with the results. After using me for a northern

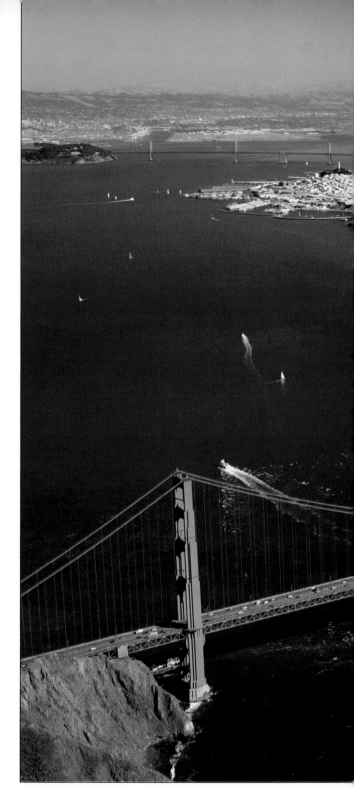

not use traditional architectural photographers because their rates are higher. I've found that with the Canon's 24mm TSE lens I can provide high-quality images at a reasonable rate, and clients are delighted to have professional looking ground-based and aerial images to market their properties.

For my architectural interior work, I use existing light and three Canon flashes, the 580EX, 550EX, and the 420EX, the latter as a slave flash, to brighten areas that need it. However, most of my work is done using existing light, often with a tripod.

I think many students may expect to do high-end architectural photo shoots and pride themselves on charging higher fees, but few succeed. Wiser shooters turn to markets I service from which they can earn a good annual income.

HOW I WORK

I shoot by myself, keeping costs low. However, I had one job to provide ground-based architectural photos of approximately twenty buildings in a large business park near Stanford University. My office assistant came with me so we could shoot the job in one day. We

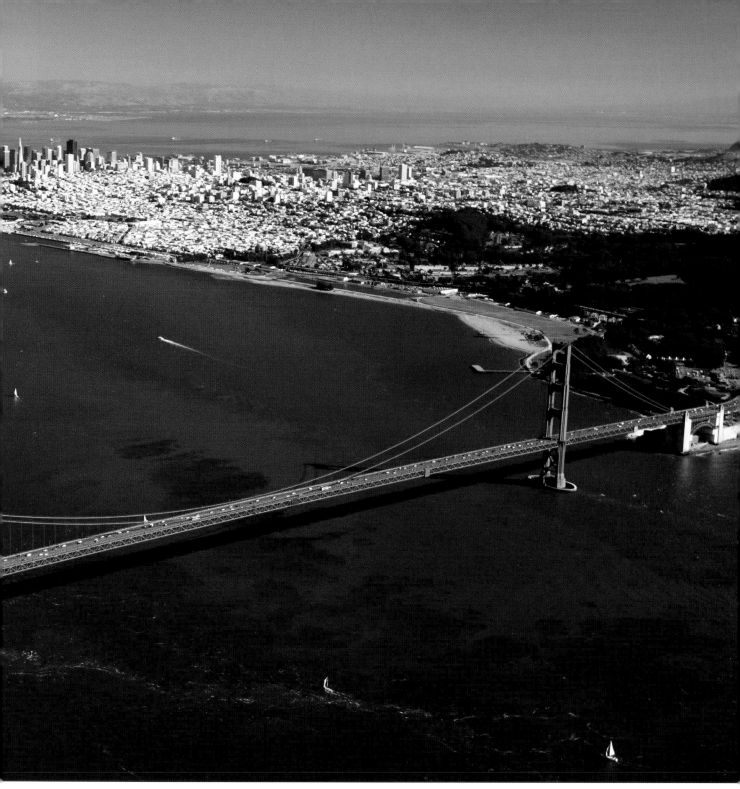

mapped out each building and the direction it faced, along with a route that matched the buildings' orientation to the sun. He drove to avoid parking the vehicle twenty times. I'd step out, get eight to ten views of a building, and jump back in the vehicle so we could move on to the next site. It was a long day, but we got all of the shots we'd planned for, and the client was very pleased.

OFFICE SPACE

My base is a small office park about five minutes from my home in the Sacramento suburbs. Few customers

visit my office, and I like being close to home. The office, which I share with a full-time assistant, is 500 square feet.

When I return to my office after a job, I download and sort images with instructions on what needs to be done for each client. Tim, my full-time employee, is responsible for further digital editing and print work. We use an Epson 9800 professional printer and a mounting/laminating system by ProSeal, both of which require a fair amount of space. I'm away shooting most days, and Tim delivers images as quickly as possible to surpass clients' anticipated delivery time.

AERIAL TECHNIQUES
Higher-resolution digital SLR cameras and lenses do a fine job without need for special equipment. Typi-

cally we fly 1000 feet or more from our subjects in metro areas to meet FAA regulations. When the airspace includes dust, fog, smog, etc., jobs may be postponed until atmospheric conditions offer higher image quality. For stability, some aerial photographers use a gyro [gyroscopic stabilizer] attached to their camera, but I've found that with fast lenses, a gyro isn't necessary except in low-light situations, around or after sunset.

For straight-down photographic views, my pilot has installed a hole in the belly of his Cessna Cardinal 177 over which I built a simple camera platform including a video device from the Skyeye Corporation over the finder. The device is 12-volt powered and connects to an inexpensive battery-operated mini DVD player to display the camera image. The monitor sits on my lap as we fly, and I make exposures using a cable release.

This setup allows us to do one-shot vertical images of sites for developers, such a golf course where we made four flight lines of five or six images each from 5000 feet. The images were stitched together in Photoshop to create a seamless panorama with excellent resolution.

DEALING WITH CLIENTS IN THE SKY

I try to convince clients not to be on site during my aerial or architectural sessions to avoid potential problems. In the past, a client-scientist came along on a flight over potential endangered species but failed to tell me he was subject to motion sickness. About two-thirds through the flight he was very sick and we had to land as soon as possible. On touch-down the client passed out, and we summoned the medics.

During a helicopter shoot another client indicated in about thirty minutes she needed a bathroom. This didn't fit our two-hour flight plan, and by the time we found an airport restroom we had to reschedule the rest of the shoot for the next day. The client had to pay for the costly delay.

WEATHER WORRIES

When I know a client's deadline, I ask what type of weather they are willing to live with. Winter in Sacramento can be foggy or overcast for weeks. Haze and smog can be problems too. On the ground, a client can see what they think is a gorgeous blue-sky day, but from the air, atmospheric interference can be terrible, and they don't understand why until they see the photos they insist I take against my better judgment.

In 2008, there were 1700 fires burning throughout California, disturbing visibility for over two weeks. One client requested that I shoot two sites as the sky looked to be improving. I indicated that conditions were still undesirable. The manager insisted I shoot anyway, and they were not happy with the results, which meant a reshoot later. I had warned them, and they had to pay for imagery they didn't like, plus new ones.

USAGE RIGHTS

When quoting a client about usage, I stipulate their rights, which vary by project and client requirements. The majority receive rights to reproduce the imagery for their Web content, publications, and marketing collateral. Imagery may not be given to third parties without my consent. Copyright information is embedded in each digital image via Adobe Bridge, which allows for batch marking. The copyright symbol shows up in the file name when a client opens the image. We do not copyright stamp the image, as that would detract from its usefulness.

BUSINESS ESSENTIALS

My unwritten business plan has been successful largely because I did not base my pricing to match others offering similar services. I don't know what local competitors charge. My prices are based on my added value, quality, and volume, and it has worked well. Revenues have grown substantially. In my first full year, I grossed approximately $90K, and business grew three-fold in five years. I've offered fair prices and great customer service, and volume followed.

I have an accountant and a bookkeeper who take care of tax issues and pay my bills. All of my data is entered into QuickBooks.

TIME OFF

I take regular vacations with my wife and six kids. We plan a few weeks a year for longer trips and take three or four days off at various times of the year. My assistant answers calls and takes care of ongoing client needs. He refers clients who can't wait to my local competitors when I'm on vacation. It's my way of providing great customer service. If my competitor does a better job than I do, he deserves a new client, but most clients come back.

MARKETING

Much new business comes from referrals. Word-of-mouth advertising can grow your business faster than any other form of marketing. I also worked with a search engine optimization firm that moved my web site from the thirteenth page on Google to near the top of the first page. That has been key to many new clients finding my web site, which then grabs their attention. My home page was designed to convince viewers within two or three seconds that I can take great aerial photos of their projects.

IN THE FUTURE

I've dabbled a bit in aerial video and have plans to start providing 360-degree virtual panoramic aerial images, which are easier to capture from a stationary helicopter. I'm able to capture about a 100-degree view with five or six stitched-together, high-resolution images that can be printed up to 3x8 feet and larger for corporate boardrooms. The 360-degree panoramic images would mostly be for Web use to show, for instance, where a new condominium complex might be built. It would require up to four cameras with wide-angle lenses, fired simultaneously.

ORGANIZATION MEMBERSHIP

I belong to the Professional Aerial Photographers Association (PAPA), a fine group with members from around the world. With the Internet and e-mail I am only a few keystrokes away from communicating with knowledgeable folks everywhere. It has been a great source of camaraderie, as the photography business can sometimes be lonely.

PHOTOGRAPHER'S PERSONALITY

Personality has a definite influence on your business. I believe the success of my company is due in large part to the fact that I tend to be positive when talking to clients. Professionalism is key. One needs to keep a healthy distance but become a member of their team, while remaining true to business and personal goals. I have based my business on the gentlemen's handshake principle. I don't like contracts. I tell new clients that if they hire me, I will deliver, and after delivering, I expect to be paid. I've had just a few deadbeats. I think people find my attitude refreshing.

7. SAL SESSA

Sal Sessa started college when he was twenty-six years old, having spent what he refers to as his "lost eight years" traveling around the world. He ended up in Denton, TX, where he enrolled at the University of North Texas (UNT). There he studied design and media, which required a 35mm camera to produce a slide show. He bought a Minolta, and he loved the medium. After college, he met a magazine photographer who offered advice, and Sal went back to UNT for a master's degree in journalism and worked on the school newspaper. He met and married Beth after both graduated, and Sal took a job with the Lewisville News.

BACKGROUND

Early in my career I worked at a newspaper, and when the newspaper business didn't work out, I got a job at a Dallas photo lab. When my friend Angela told me a lab client (a hotel) needed a photographer for a quick PR shot, I called them, and my experience made it easy. My friends at the lab processed the shots quickly, and I delivered them that day. It was an eye-opener because the client paid equal to a day's pay at the lab.

After that, I was frequently called to shoot at the hotel. My work at the lab slipped as a result, and I was let go. The epiphany came when Angela casually said

she'd get me more photographic clients. My wife and I agreed I would try a year in the freelance business; if it didn't pay off, I would give up my self-employment. That was eighteen years ago, and I've never gone back to a salaried job.

EARLY CLIENTS

I've always worked from home, and I was lucky at the start to get two really nice accounts. JCPenney had just moved to Dallas from New York, and its two staff photographers were engaged in establishing their studio. GTE was in a similar situation. They had things happening all the time, and I realized I could provide their photography for what they perceived to be a bargain, and a few hours' work would triple what I made on a lab salary.

Both companies were great to work with, and I was "passed around" within the companies until I was fa-

miliar with many operations. Attending corporate events, I got chummy with the VIPs, and as a non-employee I was able to be myself. I was not an ordinary "yes man," and they liked my casual attitude. They kept calling, and I added other accounts along the way.

The double-edged sword was that the two companies became 60 percent of my business, and when JCPenney had a staff of fifteen photographers, there was a management change and I was out. GTE's division became Verizon. My contacts were gone. Lesson learned: maintain a diversity of clients. It took me about five years to get back up to speed.

EVENTS RECALLED
• At a luncheon where JCPenney was rolling out an Elizabeth Taylor perfume line, the actress drifted into the event with her husband at the time.

Everyone just stared, not knowing what the protocol was. Someone broke the ice, and it went well, but I was initially afraid to take pictures. Her bodyguard, of all people, eyeballed me and gave me a "go ahead." She turned out to be a very pleasant subject.

- George Foreman was a blast to work with at a GTE gathering. He hammed it up for the camera and the client.
- I attended events with VIPs fairly often. We traveled in the company jet where I practiced being laid back. On arrival, I'd photograph a VIP speaking and later mingling, then we'd fly back to Dallas. I enjoyed this work and could make people feel comfortable quickly.

CHOOSING FROM THE EVENTS MENU

There are many types of events. You can try to do it all or concentrate on what you prefer to shoot. I've stuck

with the events and the types of people I want to be around in nice settings. In general, I avoided events for the general public, as a personal choice.

I apply my photojournalism background and love of documentation by shooting corporate events, which typically involves getting candid photos of folks and activities from various angles. I usually cover con-

ventions, trade shows, corporate parties, openings, award ceremonies, and press conferences. I feel there are many other photographers willing and able to do jobs I avoid. When I get requests to shoot weddings or take pictures of children, I refer people to other photographers in the area.

THE USUAL APPROACH

I bring a lot of gear to each event, though for the most part I'm dealing with on-camera flash. Getting the shot is more important than creating a work of art. It is also of utmost importance to make your client look good. Embarrass yourself by messing up, and someone will be coming down on your client for hiring you. If I'm faced with a job where I don't feel I can give the client the best quality of coverage, I bow out early and refer someone else with better experience or equipment. For example, architecture and product

shots are just not my cup of tea, and others who do them well will eventually send me referrals.

FINANCIAL CONCEPTS

Being a one-man-show means keeping your own business records. On that score, I've found I make about half of what I bill. For every $1000 I charge, I keep about $500. It costs me about $500 a day to stay open, which means billing about $120,000 total a year. That's based on $6000 for a twenty-workday month, the cost to pay my business and personal bills. A formula does depend on regional cost of living and your lifestyle. Figure what you need to make monthly to pay your bills, and you will need to at least double it in bookings.

My theory is that by attrition you lose about 30 percent of your business every year. Clients get fired, move on, or move up. If you replace a third of your

clients every year, within three years you will be doing well. The trap is that when you get a few nice accounts, you may be tempted to rest on your laurels. To counteract attrition, ideally one client should not comprise more than 10 percent of your income. Try to deposit some checks in a separate account so you can fall back on the cash when business drops off and you need an income stream.

DALLASHEADSHOTS.COM

I have made head shots and portraits a separate service. When competition increased in my corporate event business, I realized that companies were going to need more professional employee headshots, and I decided to tailor that service for company convenience with appropriate price and quality. I developed the web page Dallasheadshots.com using previously photographed headshots and executive portraits as examples. I worked out a reasonable pricing schedule and began selling the service to my existing corporate clients via search engines, using descriptions for good placement on different indexes.

I photograph a minimum of five subjects at the company offices, for a fixed fee. If a company wants additional portraits, I add to the minimum on a price-per-head basis. The total is less than individuals would pay at a studio, and it's a suitable rate for my time. The key is to do them all using a simple soft lighting arrangement that suits most faces, with just a slight modeling effect. I use two umbrellas, more front lighted than side, with no hair light.

The background folds up into a 3-foot circle, expands to 4x7 feet, and is convenient to transport. I can do five headshots in under two hours without an assistant (a half-hour setup, an hour of shooting, and a half-hour breakdown). I post the proofs on my web site the same day, and within three days I mail a CD containing one (each) 5x7 high-resolution print with minimum retouching. The proofs and CD are included in my fee.

The system also works in quantity. With two or three assistant photographers, each with a matching setup, we've done as many as five hundred head shots

in a day. With experience you become very efficient. "Hi, how are you? Put your arm here, turn your head this way." We identify subjects by photographing an 8x10-inch card with a last name on it before taking pictures. Later, the client can arrange the pictures in alphabetical order in their files, and we match names with faces. With mass production, we shoot only four or five frames per person. Clients love our service because they get an archive of all who attended an event. Headshot service is an option that other photographers now offer.

BUSINESS PROMOTION

I have tried many promotional methods, and most did not work. Since event work is often a once-a-year assignment, many folks forget your promo piece before their next event. I have tried trade magazine ads, cold calling with a follow-up promo piece, and appointments. I have tried joining trade organizations. All the above were more or less worthless. The one big, break-out success for me, and for most photographers, has been the Internet, and in particular Google and Yahoo search engines. Through careful placement of key words, title, and description, I was able to float to the top of page one with most searches. This has been most successful with out-of-town clients researching photographers for a Dallas event.

I believe the more work you do, the more work you get, so I constantly promote myself on the job by giving my card to whomever I can. I also carry with me a few hundred postcard-style promo pieces, with photos and info about our services. My business has grown in the quality of assignments, but not as much in the quantity of work I would prefer. I live in a world of feast or famine, and sometimes making a living can be a real challenge.

PHOTO EQUIPMENT

I use Nikon D300 bodies with MB-D10 battery grips, plus a Nikon D3. My Nikkor lenses include a 14–24mm f/2.8, 24–70mm f/2, 70–200mm f/2.8, 20mm f/2.8, 85mm f/1.4, and 35mm f/2. I like a long lens at times to ensure an out-of-focus background. I use AlienBees monolights and Nikon SB-800AF Speedlights. I have four cases, including a Rock N Roller multi cart. My postproduction work is done on an Apple Mac Pro or MacBook Pro.

USING STUDIO FLASH

I'm often called on to photograph groups of varying sizes. When I am, I take five AlienBees units and typically need to set up just four. When photographing a large group, I put the light units on 13- or 8-foot stands, on either side of the camera. When I am hired to photograph smaller groups, I bring four lights but generally need to use just two. An assistant stands in the setting and we establish even lighting. Later we arrange people by height, with the VIPs in the front. During flash recycle time, I keep talking to maintain total eye contact.

POSTPRODUCTION WORK

I do proofing myself using Adobe Photoshop CS3 and Lightroom 2.0. I eliminate all but the best shots, tweak everything, and use Lightroom's Web feature to create a flash-based online proof page. I upload this to a web site and give clients their proofs within twenty-four hours. They e-mail me a list of choices

and I create their final files on a CD/DVD or electronic download.

CHARGING FOR EVENT PHOTOGRAPHY

Prints are about 20 percent of the business, and I output 5x7s, 8x10s, and 11x14s on my Epson Stylus Photo R2400. Volume jobs go to a lab. I create package add-ons by offering all prints from an event in 4x6 size. I have them done at Costco and walk out with three hundred or so 4x6 prints in maybe forty-five minutes.

I charge for a three-hour minimum on weekdays and a four-hour minimum on weekends, plus fuel and postproduction time. I charge the minimum fee whether the job is one hour or three, and I have a per-hour rate for additional time.

You will find a sample of my rate sheets for events and headshots at these sites:

http://salsessa.com/crs.event.htm
http://salsessa.com/crs.headshots.htm

When an event lasts two or three days from 8:00AM to 10:00PM, I negotiate a per-day job fee. Pricing your services can be a bit of an art form. I try to stay in the high–middle range. Usually the call you get is from a gopher and the decision is made by a bean counter, so the trick is to find out who is the decision maker and try to make them understand the value you offer in getting it right the first time.

COPYRIGHT PRACTICE

Many clients are not aware that photographers own their copyrights unless there's a written agreement to the contrary (sadly, some photographers don't understand this, either). Mentioning this fact to my client may mean that I will lose business, so I doubled my fee for "commercial" use for all rights and lost clients. Now I just write in "for rights to use photos as they please" for the normal fee. Actually, few buyers use pictures beyond promoting an event. Corporate events are one of the few types of photography that generate year after year business, so the less hassle, the better.

CASE HISTORY

In April 2008, *Studio Photography* magazine did a story about me. GTE sponsored a contest in which winners would be photographed with singer Beyoncé. Her record company found me on Google. I had to escort ten positively giddy young ladies to Beyoncé's dressing room for pictures with her. Afterward, I told Beyoncé's enormous bodyguard, Terrell, that if he needed anything, to let me know. Later, the press was invited to shoot her first number, and when they were escorted out, Terrell took me to the front of the stage where I shot during three more songs for my personal use and Web promotion. It always helps to have celebrities and high-ranking politicians on your site—if for nothing else, for credability.

VISUALIZING YOUR FUTURE

I try to anticipate trends and adjust accordingly, but in this day of digital photography, new and younger photographers, and a tough economy and business climate, the future isn't always clear. Few photographers get rich, but many are comfortable. It's a fun way to make a living, and I can live the American dream of being my own boss, but it is not easy by any means.

I really don't do much in the way of vacationing for various reasons, but I do manage to go away with my family for a week or so.

YOUR COLLEAGUES

I have three or four close—and competitive—photographer buddies, male and female, and we share referrals. We follow the unwritten rule of "don't hit up my client." Be charming, shoot great photos, and no follow up. I trust my clients to them, and they do the same to me. Sometimes I let them bill my client, sometimes I handle all the details and I pay the photographer. They give me the files.

Dallas is a friendly town, but the best personality wins. Prima donnas don't survive very long.

8. DARREN SETLOW

Darren Setlow of Portland, ME, was influenced by his father, the family photographer who made lots of technically excellent pictures. Darren used his dad's camera, asked questions, and received his first Nikon FG 35mm camera as a high school graduation present. He shot "tons of film" but was not considering a career in photography. His ambition was to be a film actor, but eventually he was drawn to both acting and photography. "Each offered truth or beauty in moments that I could share with others," he says. He has been a commercial photographer since 1996.

EARLY EXPERIENCES

Early on, I occasionally assisted other photographers but was worried that I didn't have enough skills for anyone to hire me. However, I accepted opportunities to shoot portraits, landscapes, whatever—and when those categories didn't pay, I switched to architecture, interiors, and design, where there is tremendous latitude for imagery. Photographic skills can be adapted to furniture, fixtures, appliances, flooring, windows, and more. Those challenges satisfied my large appetite for learning and adapting.

I was still unsure I could make a business of photography. Fortunately, my first assisting experience was with Tom Radcliffe, a commercial photographer in Takoma Park, MD. He was then shooting portraits for performing artists between commercial assignments. In both categories I discovered a lot about how to see light and shadows on a face. I assisted Tom in the studio and learned black & white printing.

After a few years with Tom, my wife and I relocated to Portland, ME, without realizing the place was full of photographers. As we settled in, I said yes to most work opportunities.

I got a job assisting a prominent studio photographer who did catalogs of home furnishings, and I

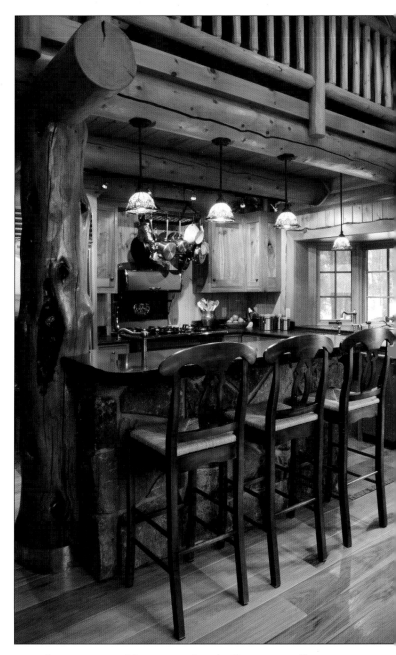

served my own architecture-related clients as well. Working with Stretch Studio provided more welcome experience in interiors and furniture, especially dealing with reflective surfaces. After two years, I moved into a studio building owned in part by Mark Rock-

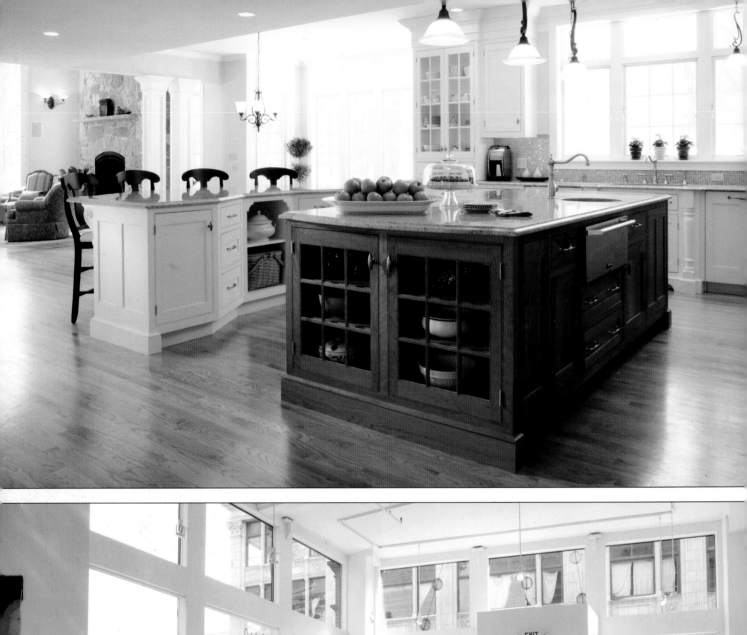
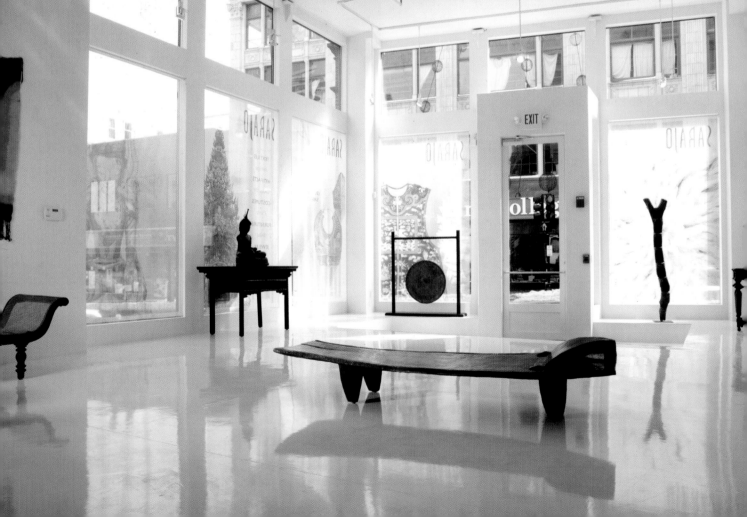

wood, who also does catalogs. Just being around his work taught me more about how to see light in my own way. Mark became an unwitting mentor, and I also picked up other occasional assisting gigs, mostly for income, but always for experience.

With the benefit of hindsight, I would not recommend starting out the way I did. Commercial photography is hard. Running a business is hard. You need a plan, you need capital, and you need a good core business reason for starting in the first place.

BUSINESS DETAILS

Photographing interiors now keeps me busy, though I find that doing furniture alone is more satisfying. It can also be quite tricky, but a well-executed image of a piece of fine furniture is gratifying. The hardest part can be finding the right angle and lens to create the most appealing and inviting tension. It is a combination of artistry and craftsmanship, and I consider myself a commercial artist who likes to be recognized for making pictures that invite the viewer to engage with the subject. The pictures have to work and represent the client first. That applies to clients who need executive portraits in addition to interiors for press releases.

TAKING PICTURES

For most interiors assignments I tether my camera to a laptop; this allows me to better check on the focus, props, and details. I currently use the Nikon D2x and rely on Nikon proprietary capture software with Adobe Bridge for viewing and adjustments. Lightroom, Aperture, and Capture One also work well for viewing.

I rarely need to shoot in a studio; however, my former office was in a building with a 1200-square-foot shooting space, last used to photograph pieces of copper gutter for a trade show. Since 98 percent of my work is location based, I moved my office back into my home.

Location shooting involves a variety of lighting and planning challenges. This chemical mixer (right) was photographed at its fabrication shop. It's about ten or

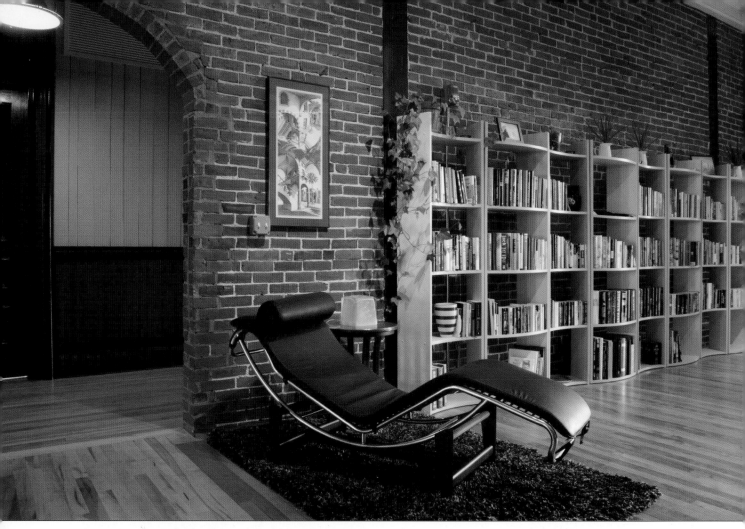

twelve feet long, five feet wide, and seven or eight feet high. We knew that the final image would float in white space, and we lit the reflective steel by bouncing light into a series of large white sheets hanging from the walls and ceiling.

LIGHTING EQUIPMENT

For most interiors, I first assess the ambient light to get a feel for the space and its design. I often make a few test exposures to find where I want to augment the light using three Speedotron 2400 watt-second packs and six flash heads, fired with PocketWizard radio slaves. Typically I put 10-inch reflectors on lights, plus a grid of varying intensity, or I leave it open, but always with Toughspun or Opal diffusion. Light intensity is dialed way back to mix with the ambient light. This generally looks believable.

I work hard to hide my lighting techniques. Often lights are pointed away from or just off the set, since most of what we see in interior lighting is bouncing from somewhere, and not always from a direct source. My softboxes are three Photoflex 24x36-inch units. For quick setups, often for portraits, I use my Nikon Speedlights with Toughspun over them, fired with PocketWizards.

LIGHTING TECHNIQUES

Regarding still life, large or small, I first consider why I am photographing it. The answer helps me plan the approach to a piece of furniture, a kitchen counter, or a china cupboard. A high-contrast scene, such as an interior with mahogany furniture, light-colored walls, and window light will be harder to shoot than a low-contrast scene where the architecture of the space is more dominant.

Next I assess the best angles to photograph the subject. I want to create the best sense of invitation to the room or piece of furniture. I look for an approach that

offers the most pleasing tension, in which the scene or object seems to snap into place, or where we see its best "personality." For interiors, this is often below eye level, at around fifty-four to sixty inches. For furniture, it's often around waist level. I try to avoid lighting a subject from the camera position, except for subtle fill. Things usually look best with a good sense of depth and texture when lights are at about a 45-degree angle relative to the camera. If this causes flare

in vertical surfaces, indirect lighting is called for. As an exercise, look around your home and observe what light is doing at various times of day.

LIGHTING LARGE AREAS

Some interiors are too large for my Speedotron lighting; other times, it's not feasible to use it for various reasons. In this case, I analyze the ambient light and decide what lights are needed to make a balanced

image with good contrast. The lighting in many new-construction interiors has been professionally designed, and I often depend on it as a guide by going with the ambient light and adding my own if necessary. However, if the view through a window is included, I light to balance interior and exterior values. A flash meter helps make this feasible.

CAMERA SETUP

I shoot with a Nikon D2x tethered (via USB 2.0 cable) to an Apple laptop, and I use Nikon's Capture Control Pro 2 and Adobe Bridge to view images. It's not perfect, but it's reasonably quick, and Adobe's Camera Raw component in Photoshop/Bridge works well to check curves before committing to a final capture. Other viewing/editing software such as Lightroom, Aperture, or Capture One have other, more robust features but work basically the same way. I use my portable hard drive to back up pictures as I work.

For most interior work I currently rely on Nikon's 17–35mm f/2.8 zoom lens, and I use my manual 50mm when there are no extreme highlights. For some portrait work I use Nikon's 70–200mm f/2.8 VR zoom lens. I'm contemplating Nikon's new D3

full-frame sensor body and a couple of new lenses to go with it, including a 24mm tilt/shift perspective control lens.

I handle perspective control in the camera as much as possible. Using a grid focusing screen, I carefully place the camera at the appropriate height and angle. For interiors, the best height for a pleasing overall view is about fifty-four inches. When the camera is level, the vertical lines will be straight. Sometimes converging vertical lines are unavoidable, or it's necessary to deliberately skew the lines to keep certain elements in the frame. For these occasions, I have visualized what the final shot will be and know where the crop lines will fall. Later I will correct the image with Photoshop's Lens Correction filter.

WORKING ON LOCATION

On location I usually have one assistant and we use walkie-talkies to communicate when necessary (in case, for example, we're setting up a dusk shot, and the assistant needs to be in the house adjusting lights to balance exterior light).

I recall a job that required an involved setup. I had no assistant because none was available on a Sunday. The home was a designer's show house, and when I was settting up, I had to work around circulating guests, who were gone when I began shooting. I couldn't start setting up until 4:30PM for a 7:45PM shoot. I had scouted this home and planned to place three Speedotron packs with two heads each, plus two Elinchrome monolights. One of the latter was in a far room of the house with just the modeling light on to balance with other interior lights. I also used a Speed-light in the foreground for the detail around the pool, and to highlight the water and enhance its cyan color.

I had just enough time to set up all the lights and adjust them for the interior. I got a few captures before the light dropped off and was able to evaluate the photos on my tethered laptop powered by an extension cord to avoid relying on the battery. I had several close calls. The pack running the lights on the trees was firing only intermittently, and a breeze stirred up, blowing out many of the candles I'd set up. I ran around relighting the candles and scurried back and forth in the house to adjust the lighting. I tried to do it all in-camera, but I knew that I could composite the best takes and make a suitable final image in post-production. The shot (facing page) came out very well with little adjustment.

HANDLING POSTPRODUCTION

I do nearly all postproduction work myself, starting with downloading my files to the main computer. I use two 500GB drives—one is the main and the other is the backup. Immediately after downloading, I enter metadata and copyright information using Adobe Bridge. Most images require enhancing curves, straightening, removing some spotting, or using perspective control. A few photos require layer masking

and compositing. I subcontract more elaborate masking, such as dropping out the chemical mixer. I also do much of my own printing—including some basic marketing materials, client proofs, and final prints—on an Epson 2400. Most jobs, however, are delivered via DVD or FTP.

USAGE AND COPYRIGHT

Educating the client on what to expect is important. We talk about my approach to the work, working on location, and how much I will charge. We reach an agreement on reproduction rights (this covers limits on how the client may use the images). Knowing what to talk about—and when to bring it up—is challenging and requires understanding the business, as well as standard usage practices, but it also requires being

sure of your own negotiating prowess and your business expectations.

Rights agreement can be tough when the market is tightening. Reproduction rights are always discussed before the shoot and spelled out in a contract. The licensing terms and conditions are always presented on the back of the invoice or on a second page. My copyright info is in the metadata for every image file. Now that the Copyright Office offers electronic filing, it has never been easier to register your copyrights. Make a program to file every image you shoot and/or deliver once every quarter to be fully protected by the statutes. Bulk filing every three months of shooting should be doable and will ensure that your published images will all be registered within ninety days of publication, and will thereby qualify for full status protection.

PRICING

I price my services based on a production fee plus per-image usage fees. Production fees are calculated by adding up all overhead costs and my fees and dividing by the estimated number of shooting days per year. Digital processing fees and expenses are added. This is a standard pricing model for photographers who shoot interiors and architecture. In some cases, clients are so deeply trained to think in terms of "day rate" that I have to price according to their expectations. The day rate increases according to the degree of difficulty and uniqueness of the images, and also according to usage.

MARKETING

Most of my business comes from referrals and through contacts made via published editorial work. I started using e-mail campaigns with a subscription to a contact database, but it's too early to tell how well this money was spent. I recommend joining trade associations; many, such as ASMP (American Society of Media Photographers) have a web site with a "find a photographer" feature. It's a great tool for getting larger exposure. ASMP member forums are also a great resource for technical information and refining your business practices. ASMP publications are invaluable for advice and insight on business practices as well.

I'm currently working on finding a rep and expanding into catalog work. I'm investigating overseas markets. Eventually, I see myself having a full-time assistant and a business manager or rep for constant marketing and to help handle my workload. I keep abreast of the latest news and trends in the shelter mags I'm interested in as well as in publications like *Metropolis, Wallpaper, I.D.,* and *Wired.*

A BUSINESS PLAN

I recommend creating a business plan and working from it. Use your plan to determine whether different kinds of jobs are profitable. Even if you are working on your own, your business plan can serve as a road map that will keep you in touch with your business responsibilities.

Marketing (and a subset of marketing, branding) is a hugely important component of running a successful business, but it is often overlooked—especially by photographers who work solo. If I could start over, with my current interest in architecture and design, I'd write a business plan to accommodate a studio and business manager who could handle the office operations, marketing, and financing.

USING AN ACCOUNTANT

I work with a CPA who advises me on how to make certain decisions, assists me with filing taxes, etc. We meet about once a quarter. She is in a position to offer guidance on investments, but I also have a financial advisor.

A PHOTOGRAPHER'S PERSONALITY

Personality can have a key influence on business. You are the business, and all business is about people. Genuine interpersonal skills, creative problem solving, and handling locations and clients smoothly and coolly all make a lasting impression and help people feel confident in employing and referring you. Success is a combination of personality, photography and people skills, and business acumen.

9. MIKE SCHAFFER

Mike Schaffer of Upland, CA, started his own studio in 2002 in a 1000-square-foot artist's loft. In 2006, he took over his current studio, where he had once assisted another photographer when the latter's business failed. He has made large strides in a relatively short period. He is busy during the summer shooting products and other subjects (including Christmas catalogs, which need a lot of lead time to accommodate designers before they are printed). Mike is versatile but enjoys being an advertising specialist. For more information, visit Mike's web site at www.schafferphotography.com.

BACKGROUND

I went to Cal State–Fullerton and completed a few general education classes. When I transferred to Mt. San Antonio College, I took my first photography class. A friend and I wanted to make an independent film, and someone needed to operate the camera. However, the film only got to the script phase and fell apart. A lot of people are involved in making a film, and with no budget they lose interest really fast. I also started working at a local camera shop in order to learn more, and I met a photographer who needed an assistant. That became my introduction to commercial photography, and the year I worked for him was a continuous learning project for me; I absorbed a lot through varied experiences. When my employer's business started to slow, I decided to start my own.

EARLY BUSINESS YEARS

By doing a lot of personal projects in an effort to build my portfolio, I came up with ideas that I thought would be great photos. One of the most memorable was when I had an aspiring model friend wear a long, pink "dress" that we made out of a blanket from the thrift store. I had the model sit in the second-story window of an old, abandoned house. I had heard of a trick to photographing fire by using rubber cement to get a nice, bright flame. We dipped the bottom of the dress in rubber cement and lit it, but I was only able to shoot one frame before our fire extinguishers put out the flames. I haven't tried rubber cement since.

The photographer I had worked for was excellent at lighting and taught me much of what I know now. He also taught me a lot about working with clients, what I might expect from them, and what they should ex-

pect from me. Some clients are more creative than others, and I try to tap into their ideas and expectations. Clients are likely to expect me to come up with images that beautifully show their merchandise or services and help give their companies distinction.

CURRENT WORK

I work with a very broad range of clients, from hospitals to clothing companies. When people ask what my specialty is, I respond that it's advertising, which I really enjoy no matter the product or service. Ad campaigns offer the most opportunities because they usually involve the most creativity. I photograph lots of products as still life and also do shots of people using the items. I also work with companies producing annual reports, catalogs, brochures, and advertising campaigns.

THE STUDIO

My studio is about 2200 square feet with a receptionist's area, a postproduction office, my office, and an office for bookkeeping. There is also a room for hair and makeup, a full kitchen, and an equipment room. A roll-up door to the 40x30-foot cove shooting area opens to a gated back area. (I've photographed a car in the studio, but it's a bit tight. For automotive shoots, I prefer to rent a larger studio.) The studio is in an industrial complex with very minimal signage. Our main shooting area can be divided into two smaller shooting areas when we get busier. In the cove, all setups are created specifically for each job. However, the setups can often be revamped and reused with minor adjustments and revised lighting.

CAMERAS

I shoot with a Hasselblad H3D-31. The whole camera system with body, 80mm lens, 150mm lens, 28mm lens, and digital back costs just over $30,000. This back is built exclusively for the H3D camera system. I went with the H3D-31 because the shutter sync speed goes to $\frac{1}{500}$ and because the 28mm lens is the widest lens I could find for medium format digital. The camera is heavy compared to a Nikon or Canon dSLR, but not as heavy as my old Hasselblad film camera. Handholding the camera is very comfortable, though I mostly shoot on a tripod. This back gives me 31 megapixels, and if I shoot to a memory card, I get roughly twenty images per gigabyte.

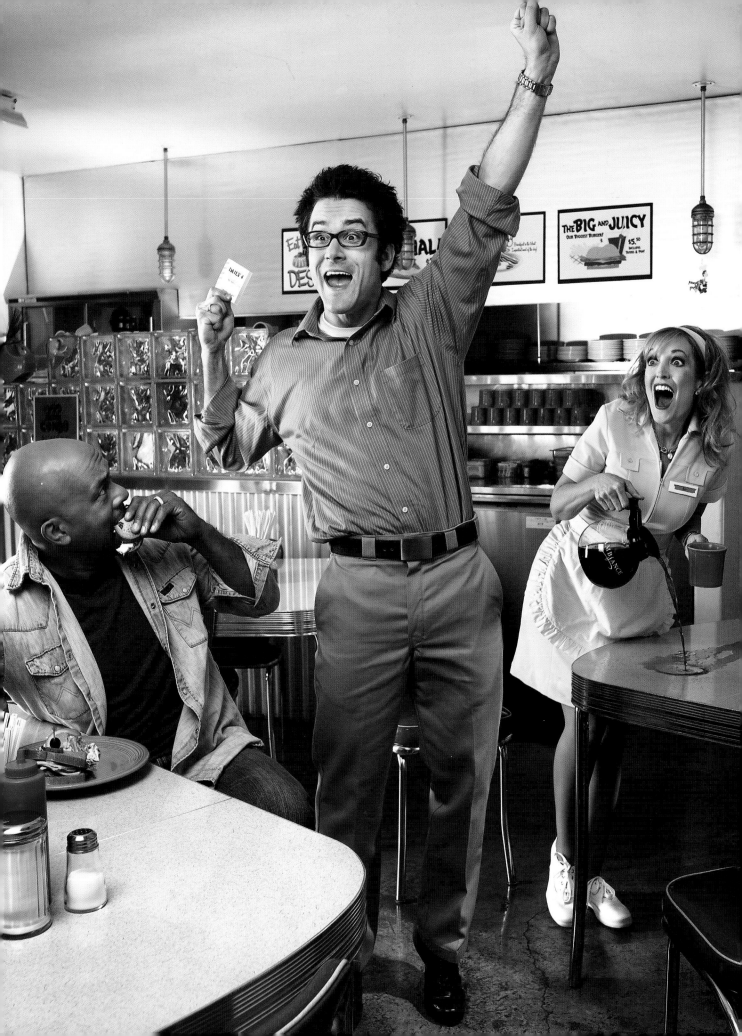

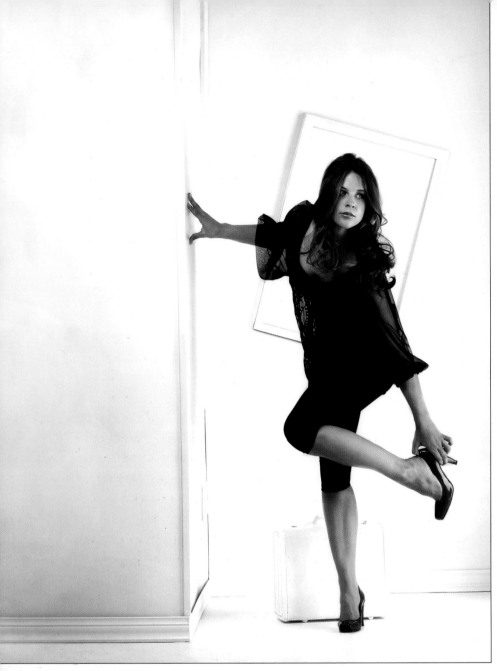

14mm, 35–70mm, and 200mm lenses. The 35–70mm is my general-purpose lens, and it works for most projects. For minimizing depth of field I use the 200mm lens, mostly for model shots, but I also like the look it gives me for product shots in an environment.

I don't generally tether the Nikon to the laptop because it doesn't work that way with Capture One. Lots of people are switching to Canon because it operates with Capture One.

LIGHTING EQUIPMENT

I use 2400 watt-second Profoto acute power packs, plus Nikon SB-800 and SB-28, Vivitar 285 and Sunpak 622 on-camera flash units. These smaller flashes are powered by Quantum Turbo 2x2s. We also use Westcott and foam core reflectors and Calumet 72, 48-, and 24-inch softboxes. The studio stocks lots of apple boxes and Matthews C stands. I also have a Matthews RoadRags kit, which includes a collapsible silk, a flag, and two scrims.

We use lots of flags and scrims and custom make foam core flags in the sizes we need. We also have a number of traditional flags that we've purchased. For our smaller Nikon and Sunpak flashes, we've made snoots out of our energy drink cans. Clients get a kick out of seeing us drinking from them during the shoot and also having cans attached to our lights.

The number of lights we use on a shoot is partly determined by the amount of time we have. The more time I can spend on lighting in general, the better the shot. However, on a catalog project, it's more important to get all the images done quickly than to finesse lighting and styling until they're perfect. But for hero shots (main images) for ads or covers, I can usually

I typically tether the camera to a laptop and shoot straight to the computer. I like having the larger preview screen of the laptop. With the camera tethered, I'm able to check composition, exposure, and sharpness, and art directors love to be able to view the enlarged shots right away. (On an outdoor shoot, I put a shade over the laptop to eliminate the glare.) I use Capture One software, and after I plug the FireWire in, it's basically ready to go.

I use Nikon dSLRs for shoots where I need quick autofocus and for jobs that don't need the kind of resolution the Hasselblad digital back offers. I use Nikon

spend time dialing in the lighting. Our studio has two full-time assistants and a few freelancers, and I'll take at least one along on location shoots.

OFFICE AND FACTORY SETUPS

I use the Hasselblad with digital back for about 90 percent of our shoots in office and factory settings. We bring the Profoto kits as well as smaller flashes. I usually set up a few staging areas to shoot, one perhaps including a tabletop with seamless paper. Another situation would be lighting a large portion of a warehouse or office with the focus on a piece of equipment or a technician at work. Softboxes are a must for these applications, as are lots of little flashes and Pocket Wizards. A lighting setup generally includes four to six lights, but larger areas may require ten to twelve units.

BUILDING SETS

I recently built a set for a Western wear company which had an 8x8-foot wall with 4x8-foot attachments to make it look like a room. The attachments are easily rearranged to give the room a different look for each shot. This particular set resembled a barn, so it had an old-looking wood floor, wood walls, and lots of props like wagon wheels, saddles, gas lamps, hay

bales, and barrels. We used this set for product shots of boots, shirts, and hats as well as for pictures of models wearing the clothing.

For more basic product shots, I cover an old light table with seamless paper. Sometimes I'll put a 4x8-foot sheet of wood on top of the table to expand it for a lifestyle type of product environment with the addition of props. I try to keep the sets as simple as possible so photographs don't get cluttered, but at the same time I'll vary the props to shoot multiple items.

CLIENT INVOLVEMENT

Any time we're working on a shoot that involves a concept, we like to have the client or an art director on hand to go over any questions we may have. On shoots that are straightforward, the client will usually be around for the beginning and leave once the job is underway. We have a lounge area for clients, and there are computers they can use to go online and check their e-mail. If they bring their own laptop, we have an office they can work from. On location, we generally have a client or art director with us. Our best client pacifier is our laptop where the client or art director can see what's going on as it happens.

I also welcome visits to the studio; this allows the client to become more familiar with our operations.

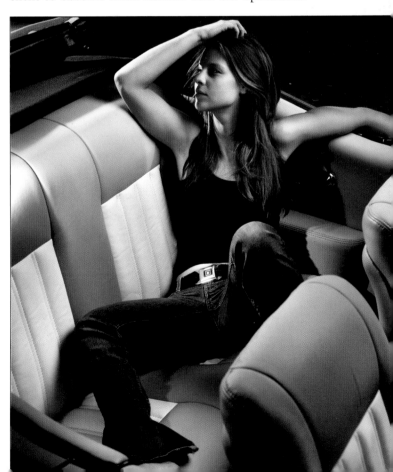

IMAGE ASSEMBLY DETAILED

An ad we shot for a flashlight company required us to photograph a teenager shining a light at the stars. The client was very specific about having a cityscape in the distant background and that the boy needed to be leaning against a fence. So we photographed the boy shining a flashlight in the studio against a light-gray background (left).

At a lake resort, we photographed the ground for the boy to stand on and a railing for him to lean against. I shot the city at night using only available light. Different sections of the cityscapes created a generic looking city when the images were pieced together. Finally, in Photoshop, stars were added to the sky and a beam of light from the flashlight was created.

For another image created for Mag Lite (facing page), we started with a rope hung from the rafters in our studio. We attached a climbing harness to the model and suspended him a couple of feet from the ground. We used six strobes to light that portion of the shot, giving it the dramatic depth shown in the final composition. Next, we photographed the bottom half of the rope, flinging it around in front of our strobes to get the shape you see trailing off the bottom right of the image.

Many times we have to educate them that what we do requires more than pointing a camera and clicking. Shooting straight to a computer works great as an educational process; however, photo illustration projects are better shot without the client around because the elements used to create the final piece don't look very exciting on their own. We may shoot separate elements that will be placed into the final piece in a way they can easily be edited and assembled to look natural in the final piece. We'll usually send a client some low-res samples during different stages of the project.

After completing the main subject photography, we moved on the the background elements. The cave-like rocks are actually part of the landscaping outside of our studio, and the sky is from a completely different shoot. After obtaining those images, everything was composited in Photoshop. We spent hours making everything look not natural but like the individual components were all part of a whole. The final touch was the beam of light streaming from the MagLite, which was produced using the Brust tool and numerous layer masks.

Today, this photograph is the largest print hanging in our studio and the one that elicits the most comments.

POSTPRODUCTION

We handle all postproduction in our office. My assistant downloads the images and processes them, making all color corrections and exposure changes. Minor retouching is also done at this time. When we get involved in photo illustration, we usually have a sketched comp (industry term for comprehensive, or sketch) of what the image should look like. We have an awesome photo illustrator working in house with us. Proofs are printed for clients on our Canon Pro 9000 printer.

A BUSINESS PLAN

When I started on my own I had a very vague business plan, which was to bill enough money to eat. I went after any job I could and didn't say no very often. Now, since our overhead is higher, we have to be more selective with our clients. It's not necessarily that we only take on jobs of a certain size, but we also have to make sure a new client isn't going to be difficult to work with because their expectations are unrealistic.

My accountant reviews our records quarterly to take care of taxes. My studio manager does most of my scheduling, books models, hair and makeup people, and handles rentals. She also mails our estimates and invoices and keeps track of day-to-day expenses.

My budget allows me to upgrade equipment as needed, and I'm looking forward to expanding our photo illustration capabilities.

MARKETING

Most of our new business comes to us by way of referral. We have a web site that also attracts business, a brochure that we mail out, and we have run trade ads in magazines. But word of mouth is by far our best means of getting new clients.

PROFESSIONAL ORGANIZATIONS

I belong to my local chamber of commerce and BNI (Business Network International), a networking group with chapters worldwide. We also belong to a local AAF (American Advertising Federation) chapter. All

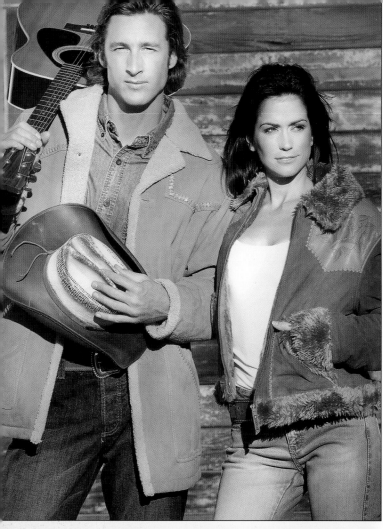

of these have been beneficial in one way or another. I read *PDN [Photo District News]* when I can, and I really enjoy *Archive* magazine.

PHOTOGRAPHER'S PERSONALITY

A photographer's personality has a major influence on business. If a client or art director doesn't like to be around you, they aren't going to hire you. It doesn't matter how talented you are. Part of my job as a photographer is to make the client's job easier.

10. CIG HARVEY

Cig Harvey was born in England and received her MFA in photography from Rockport College in Rockport, ME, where she now has a home and studio. She is an associate professor at the Art Institute of Boston, where she teaches photography and illustrated books.

In addition to being a commercial and editorial photographer, Cig is an exhibiting fine artist. Her images are in the permanent collections of the International Museum of Photography at the George Eastman House, Rochester, NY and the Houston Museum of Fine Arts.

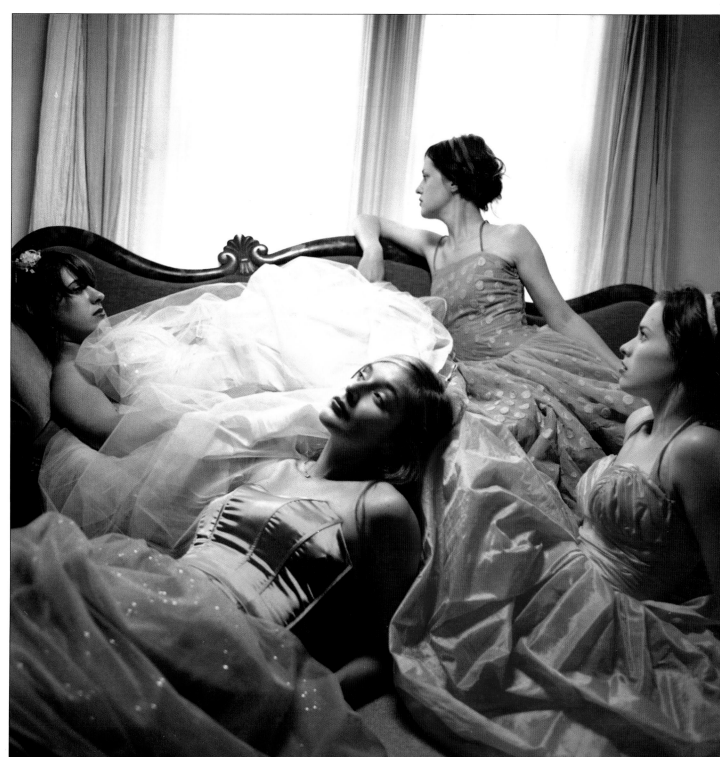

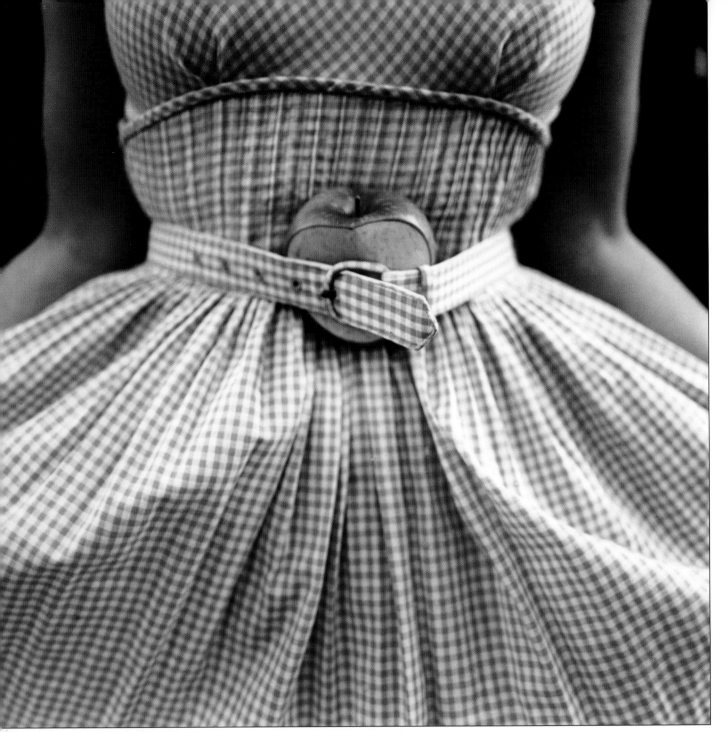

BACKGROUND

When I was twelve years old and living in England, I read *The Independent*, which featured powerful black & white documentary portfolios on Sundays. I was inspired to become a volunteer in a community darkroom in southwest England. Since then photography has remained my only constant. In my twenties, I shifted from documentary photography and photojournalism to an involvement with personal fine art.

While working for Mark Emmerson, an amazing platinum printer in Bermuda, I received the Maine Media Workshops' annual catalogs, and when Mark retired I enrolled in the Maine MFA program. Arriving there, I felt I had died and gone to photo heaven.

I was the perfect nerdy student, and I completely immersed myself in the photographic world, every genre, from historical to contemporary. I feel you have to be in photography a lifetime to do more than

scratch the surface, and I am constantly amazed by the possibilities. When I graduated I had five black & white portfolios that dealt with a personal auto-biographical story. I took the portfolios to New York and was lucky enough to get my first representation at the Robin Rice Gallery, where I still am today. I made a lot of valuable connections at the workshops, and each time I went to New York I met with people in all aspects of the industry, from fine art to commercial. Through these initial meetings, and by showing my fine art based portfolios, I found my way into the commercial world.

STARTING IN COMMERCIAL PHOTOGRAPHY

Coming into commercial photography via the fine art route is pretty unusual. My emphasis was and always will be on the ideas behind the pictures. I gave myself the gift of time during my master's studies, having saved up enough money working three jobs prior. I spent two years committing only to personal work, which allowed me to develop a strong style. Initially, the only work in my commercial portfolio was my personal work, and fortunately people in the industry felt the work could have a commercial application in addition to fine art.

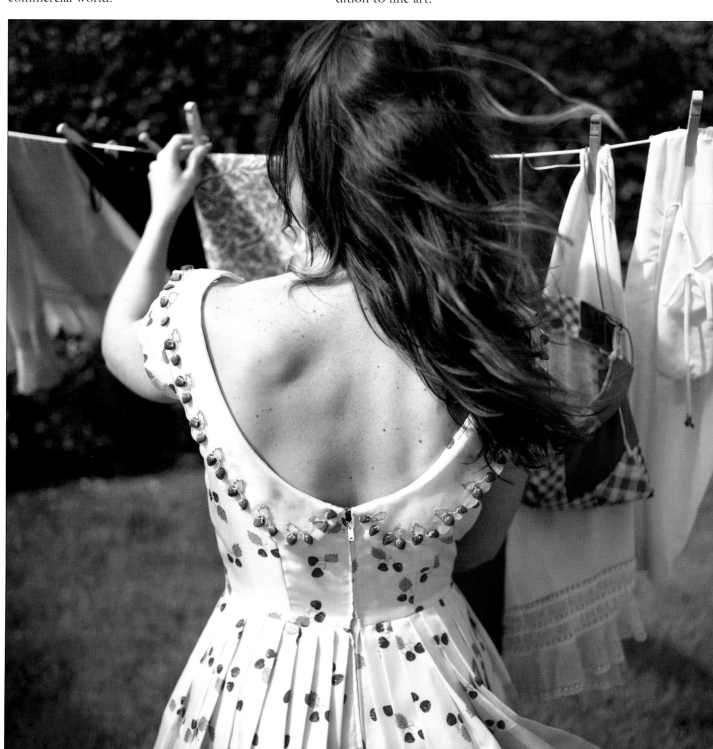

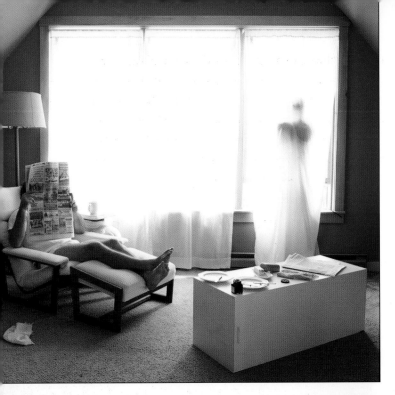

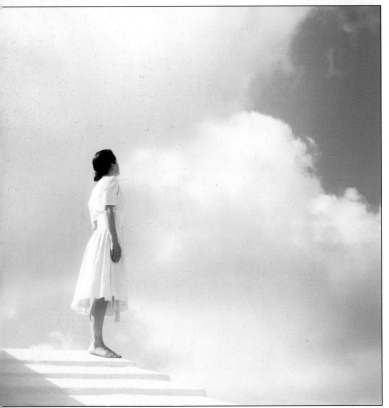

Christopher James was a mentor during my MFA era. He always questioned and pushed me to make the most conceptually powerful images possible. At the end of the day, a successful commercial photograph must contain all the same conceptual and visual ele-

ments as a fine art photograph. A good photograph transcends genres. I promoted myself by going to as many business meetings as possible, making really special one-of–a-kind leave behinds, and always sending handwritten thank-you notes.

APPROACHES TO THE WORK

My specialty is definitely conceptual. I love being given a story or a basic concept and brainstorming and mind-mapping it to explore different metaphors, symbols, and iconography. A good photograph is *about* something, not *of* something. I am interested in the ideas behind the images. A photograph is a visual manifestation of an idea, and I am trying to make the unseen, seen.

I very much think of myself as a photographic illustrator. I think I also specialize in color. Most of my assignments are very color driven and are normally a little quirky. I have a varied assortment of clients, ranging from high fashion with Kate Spade, to book publishers, to The Royal Shakespeare Company.

A HOME STUDIO

My business is a much smaller operation than most people imagine. I am a full-time associate professor at the Art Institute of Boston, so I use their C-printing facilities and run the business side of things out of my home in Boston. Last year my husband and I bought our first house in Rockport, ME. I have a specific room there that I consider my studio. It's an attic room with sloping ceilings and walls, a blue wooden floor, papier-mâché birds and pigs, old typewriters, and a thousand inspiring things Scotch-taped to the walls. It is a real gift to finally have a space to spread out that I don't have to clean up regularly.

EQUIPMENT AND PROPS

On assignment-based jobs, I typically work with a film crew rather than using a traditional photo setup. We use HMIs to augment daylight and grip equipment (reflectors, flags, screens) to control, bend, and shape the light. This equipment is the same for studio and location assignments, and it comes from my back-

ground in fine art, making autobiographical pictures, when I could choose the time of day (the right light and weather) to make pictures. You don't have that luxury with commercial work since so many people are typically involved. I really like to see the effects of light, which is why strobes feel alien to my work.

My favorite thing to do on a day off is to go treasure shopping. I hunt for unusual props and clothes of certain colors and patina that will eventually appear in my pictures. I work on the sets myself or work very closely with the set designer/prop stylist. Set design is a major factor in my photographs. People sometimes think that it is the type of film I use that creates the intense color in my pictures, but often it is the styling that gives my images their intensity.

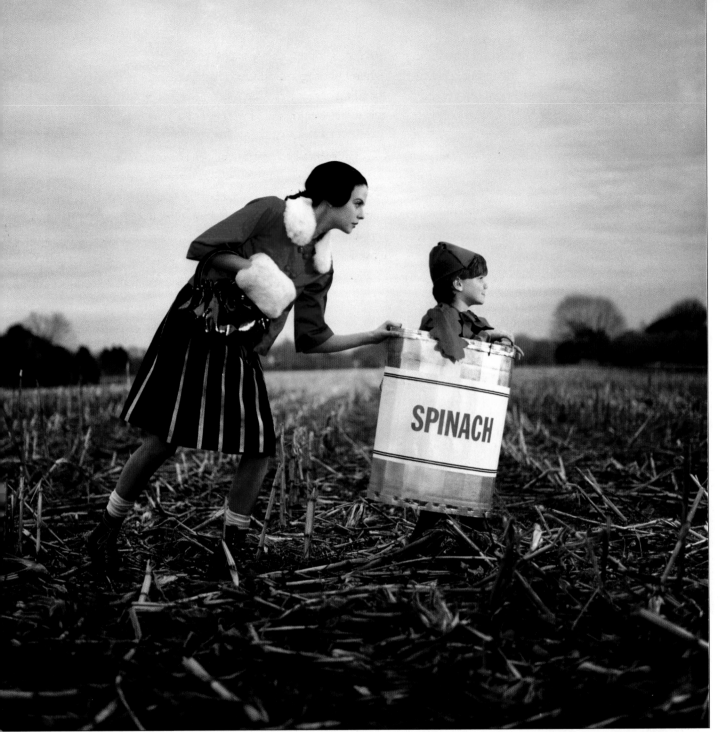

LOCATIONS

I am constantly searching for locations that inspire the imagination. I have a virtual scrapbook in my head filled with different spaces that could potentially work in a picture. I like to get to know these spaces well and see them in different kinds of light and weather to get a true sense of their potential. My favorite type of light to work in is overcast daylight. I love even, beautiful light with a full tonal range that allows my subjects to glow and offers me the possibility of adding a little sparkle here and there with reflectors. I work in color negative film and like to overexpose it a few stops, so contrasty light situations are tricky for me.

Weather can be an issue on location. During a snowstorm, my crew built a tent for me to shoot from to keep the camera dry. There is never a dull moment.

We laugh a lot on the set. When we are laughing, we are being creative. We love constantly trying out new ideas. My assistants are all visual artists whom I greatly admire, and I welcome their ideas. I usually work with the same core group of hardworking people, and I also like hanging out with them after we have wrapped up.

In regards to settings and sets, I like to give the illusion of simplicity. I think a strong photograph should feel like it was made effortlessly, though this can oftentimes be opposite of the truth. I don't like to show my hand.

EDITORIAL AND PERSONAL WORK

When I photograph people on assignment, it is always for editorial or advertising work. I like the challenge of this work; I enjoy thinking fast to find the best environment, atmosphere, and the most conducive light to convey the person or story I am photographing.

I also make pictures every week purely for myself with the goal of using them in the current fine art portfolio—there is always one I am working on. It is very important to me to maintain a balance between work I am doing for others and for myself.

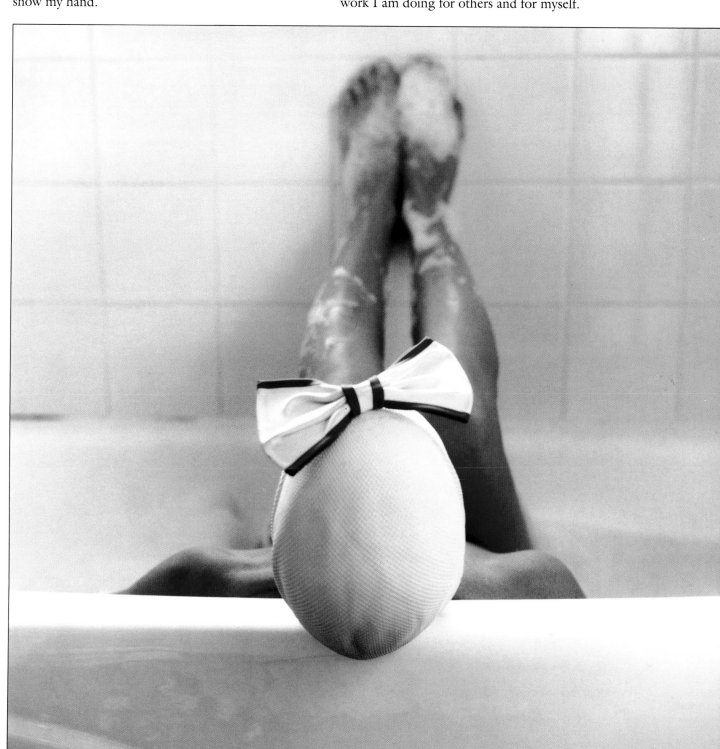

EXHIBITIONS

My exhibitions are all based on the portfolios from my personal work. I tell visual stories based on my life experiences and those whom I am surrounded by. I have always been drawn to times of fragility and use photography to explore and legitimize moments of struggle, elation, wonder, and doubt. Pictures show me that life can be as magical as fiction. Occasionally I am

lucky enough to make a picture while on assignment that I feel has the depth and the conceptual strength to make it into a portfolio. An example of this is the cave image (below). I made this while shooting a job on global healing for *Prevention* magazine, and it fit perfectly into the ideas I was exploring for my personal work at the time.

REFLECTIVE SUBJECTS

I have no special setup for photographing glass or reflective materials other than being very aware of what is being reflected and moving things for corrections. Often when I am working, I will hear the art directors on the set talking about how they fix things in post-production. I hate that idea. I love to get the image just right in-camera. I guess I am just an old-school type of girl.

CAMERAS AND LENSES

I use a standard Hasselblad 503 with 60mm, 80mm, and 150mm lenses, typically with a tripod. I don't shoot Polaroid as I feel it gets in the way of the flow of a shoot. Choosing a lens focal length depends on the conceptual idea. It evolves from how I want the pictures to feel.

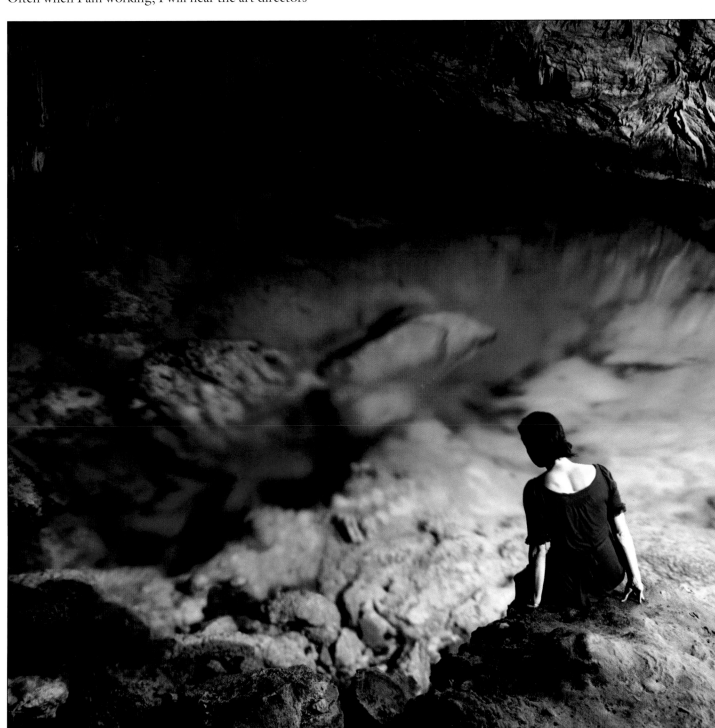

CLIENTS ON THE SET

I leave the clients' presence on a shoot totally up to them. I can work with or without them. In any case, I try to create a fun set with laughter and intelligent conversation. What I love the most about commercial work is the opportunity to meet, work with, and spend time with creative people, from the art directors, to the subjects, to the set stylists, to hair and makeup artists.

I like slow sets, and because I use a slow film and no strobes, it limits how fast things can move. I always sit down with the models or subjects before I start shooting and talk about the nature of the shoot and my expectations. I also let crew and/or clients know that we are going to do the safe shots and then play, get creative, and see what happens. Often the best images come during this time.

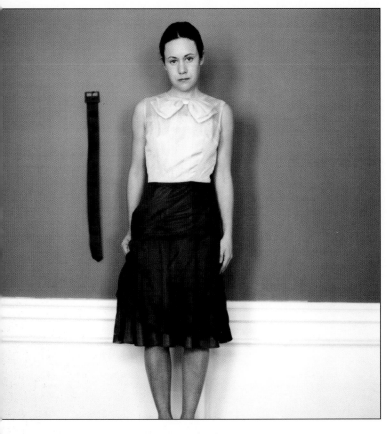

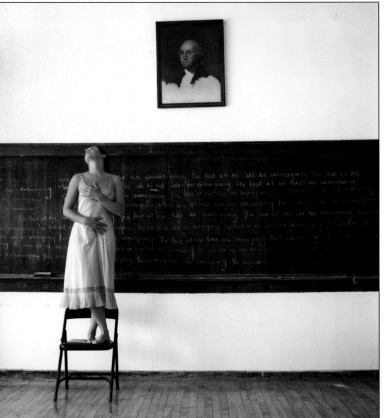

MODELS

I do hire models. I like to work with high-end models and actors, but I also like to photograph normal people such as friends, people I meet on the street, or friends of friends. The sort of in-between area in posing tends to get strange for me. When models try too hard or are concerned with how they look, it makes for awkward pictures.

POSTPRODUCTION WORK

I typically handle almost everything myself, but I employ a couple of amazing people on a freelance basis to help me with some postproduction operations. I have no full-time studio manager. I send clients the contact sheets and prints that I make in the darkroom.

CONTRACTS, PRICING, AND COPYRIGHT PROTECTION

I am lucky enough to have an amazing agent, Marilyn Cadenbach, who takes care of all the contracts, invoicing, and legal issues. The contracts stipulate usage rights and terms. I typically work for a creative fee rather than a day rate.

A BUSINESS PLAN

I do have a business plan, and I meet with Marilyn every January to go over goals for the year. Our discussions and plans cover everything from specific financial goals to dream assignments, pro bono work, promotion materials, and streamlining problem areas, like trying to do everything myself!

WORKING WITH AN ACCOUNTANT

I meet with my accountant once a year, and I now have a bookkeeper who works on a regular basis, so at the end of year the work doesn't seem so overwhelming. I am dyslexic with numbers and dislike doing the financial side of business, so a bookkeeper is a wise investment in terms of time and my personal happiness. I need to concentrate on making pictures rather than doing paperwork.

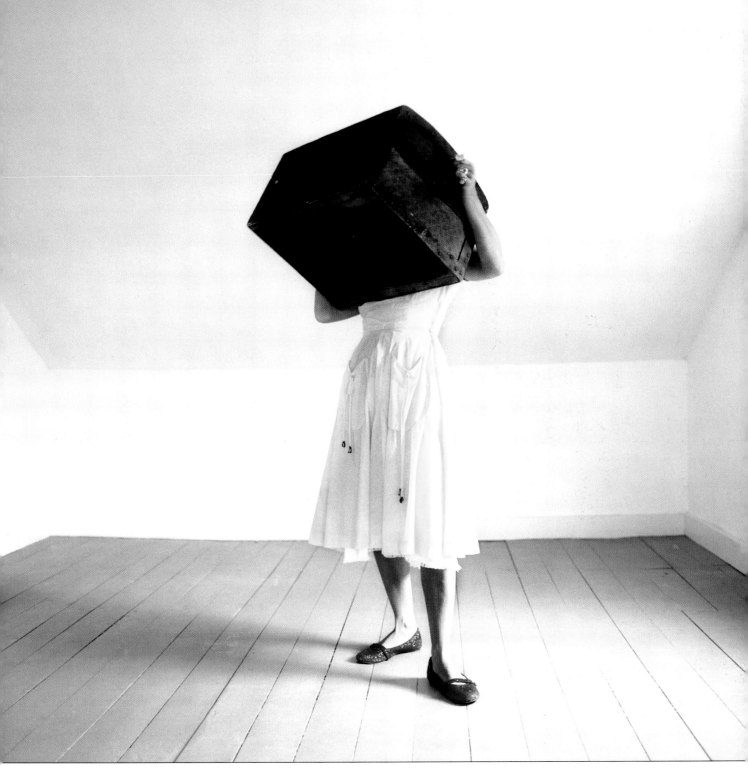

TIME OFF

I take time off as needed and when needed. During the academic year, I am based in Boston, and I work from Rockport, ME, in the summer. I have family in Bermuda, so I spend quite a bit of time there as well. Business continues as usual regardless of where I am.

In this age of the Internet, you can conduct business from anywhere and fly for shoots as needed.

MARKETING

My web site (www.cigharvey.com) and Marilyn's web site (www.cadenbach.com)—and of course the all-

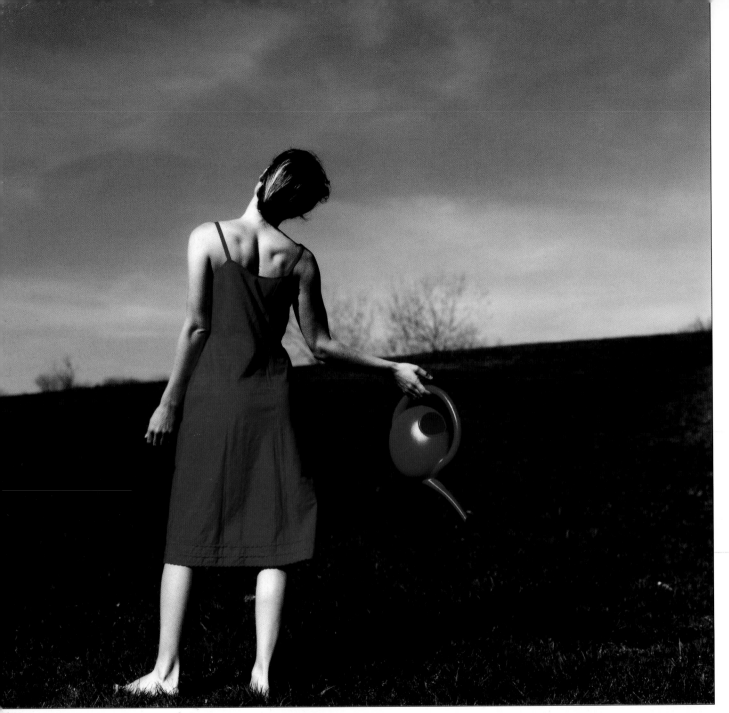

important word-of-mouth referrals—keep my business thriving. Every year, I design a series of printing press promotional cards that are mailed to a very specific client list of magazine editors, art buyers, and creative directors.

PROFESSIONAL ORGANIZATIONS

I am a very low key member of ASMP. I love *PDN (Photo District News)*, and their editors have been a huge reason for any success I have achieved. I was part of the Emerging 30 list in 2005 and was profiled by the magazine in 2004, which really kick-started my commercial career.

IMPORTANCE OF PERSONALITY

A photographer's personality is absolutely an essential part of his or her success. I try to meet with potential and existing clients all the time, and I would much prefer to go with my portfolio than to send it by messenger. Clients like to know that the photographer

they are going to be working with is cool. Nobody likes to work with difficult people or drama queens.

For me, finding the balance between commercial, fine art, and teaching is often difficult. Yet all three are fundamental to my happiness. These disciplines feed off of each other, and I feel so very lucky to be in-volved in them all. The best advice I could give any-one going into commercial photography is to make your work first and foremost. Find your voice in the process and then find the niche in which to market it. No matter which photographic specialty you choose, your work has to come first.

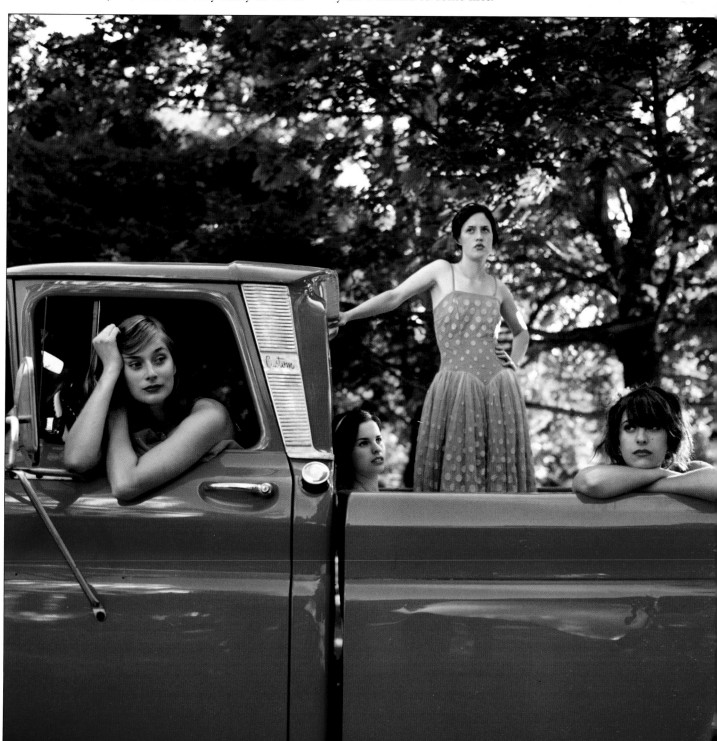

CONCLUSION

I have just spent some rewarding time reading the page proofs of this book, edited by Barbara A. Lynch-Johnt. Since a book's gestation time may be longer than that of a human baby, I enjoyed rereading what ten top-notch photographers gave me in response to questions I asked them. And since my specialties have been photojournalism and fine art photography, I relearned a number of facts about commercial photography.

When you read the book, I assume you may have also benefitted by absorbing assorted information about how commercial photographers operate. You may have also discovered that this field spans many categories such as still life, fashion, advertising, architecture, aerials, corporate portraiture, small objects like jewelry, huge objects such as industrial machinery, events such as business meetings, all sorts of product photography, and more.

I notice similarities in attitudes and techniques among the photographers, and I notice interesting differences. They are all agreed that skillful lighting effects are quite basic to success, as is a photographer's personality. If you are not personable—if you are grumpy—clients will not want to work with you. If you are upbeat and empathetic with clients and understand their objectives, life will be easier for you and for those you work for. If that sounds obvious, you probably know someone whose personality upset his or her business.

If you opened this book here at the end and you are intrigued to start at the beginning, you will be doing yourself a favor. You may learn enough to improve your own business and photo skills, and you may generate ideas that will come to you because of what one of my experts described or suggested.

Commercial photography can be fascinating, and it's also diverse. Many photographic streams run into the big commercial river.

Good luck!

INDEX